A DRAGONS AND DOODLES COLORING BOOK

T0253016

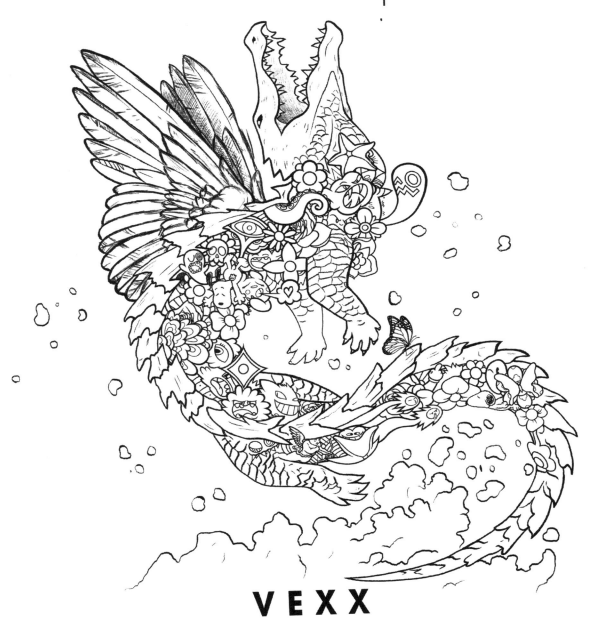

VEXX

A TARCHERPERIGEE BOOK

tarcherperigee

an imprint of Penguin Random House LLC
penguinrandomhouse.com

Copyright © 2022 by Vexx Studios, LLC
Penguin Random House supports copyright. Copyright fuels creativity,
encourages diverse voices, promotes free speech, and creates a vibrant
culture. Thank you for buying an authorized edition of this book and for
complying with copyright laws by not reproducing, scanning, or distributing any
part of it in any form without permission. You are supporting writers and allowing
Penguin Random House to continue to publish books for every reader.

TarcherPerigee with tp colophon is a registered trademark of
Penguin Random House LLC.

Most TarcherPerigee books are available at special quantity discounts for bulk
purchase for sales promotions, premiums, fund-raising, and educational needs.
Special books or book excerpts also can be created to fit specific needs. For
details, write: SpecialMarkets@penguinrandomhouse.com.

Trade paperback ISBN: 9780593419564

Library of Congress Control Number: 2022939708

Printed in the United States of America
1st Printing

Book composition by Lorie Pagnozzi

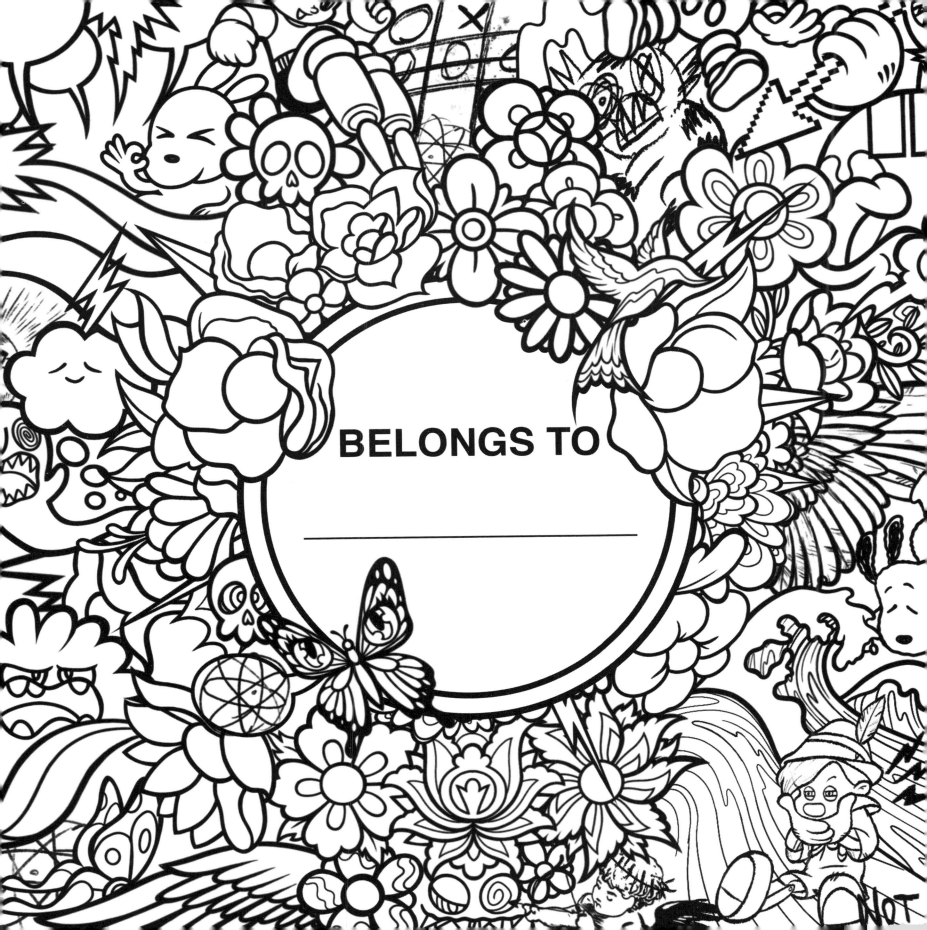

BELONGS TO

WELCOME BACK TO
THE DOODLING WORLD OF

In these pages, you'll find an array of mythological creatures and Vexx classics, from dragons and unicorns to full doodles, tigers, and skulls.

We also invited a handful of guest doodle artists from our incredible community to participate with a few of their own doodles inspired by their own cultures, influences, and experiences. You will find these scattered throughout the book.

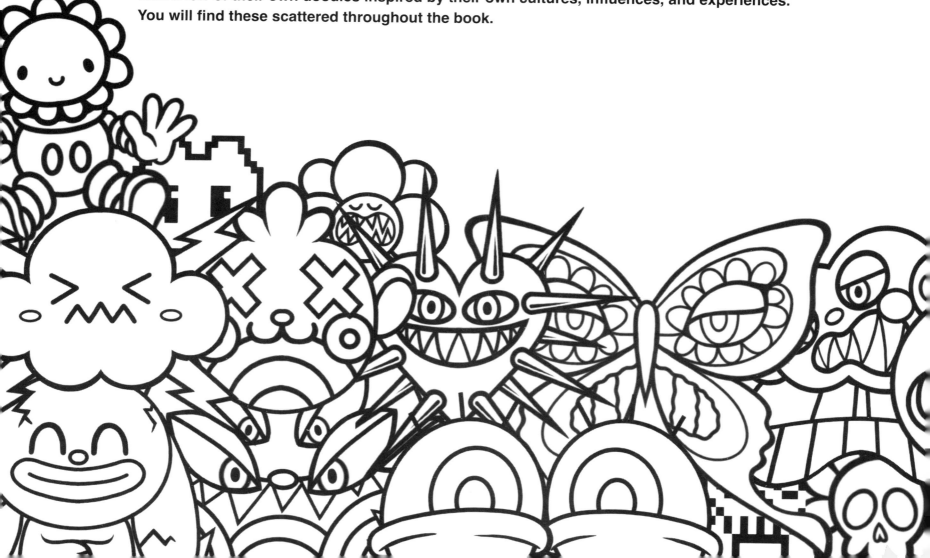

My purpose with this second coloring book is to focus heavily on elevating the quality of the art, showcasing more detailed doodles and intricate overall compositions.

I hope this book continues to inspire you in your life, both inside and outside of the art discipline. Whether you use it as a quiet activity in your downtime or in the development of your own creativity, I am grateful that you've decided to take this journey with me.

TIP: If you use markers, add a piece of scrap paper behind the page you're working on. This will help ensure the ink doesn't bleed through the page onto the next drawing.

I can't wait to see your creations! Tag @Vexx and use #Mythotopia.

—VEXX

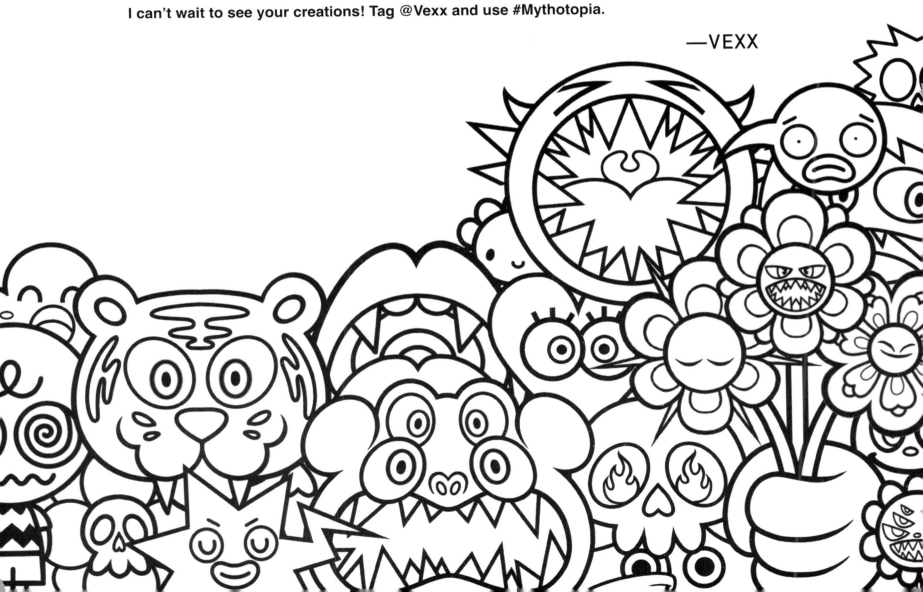

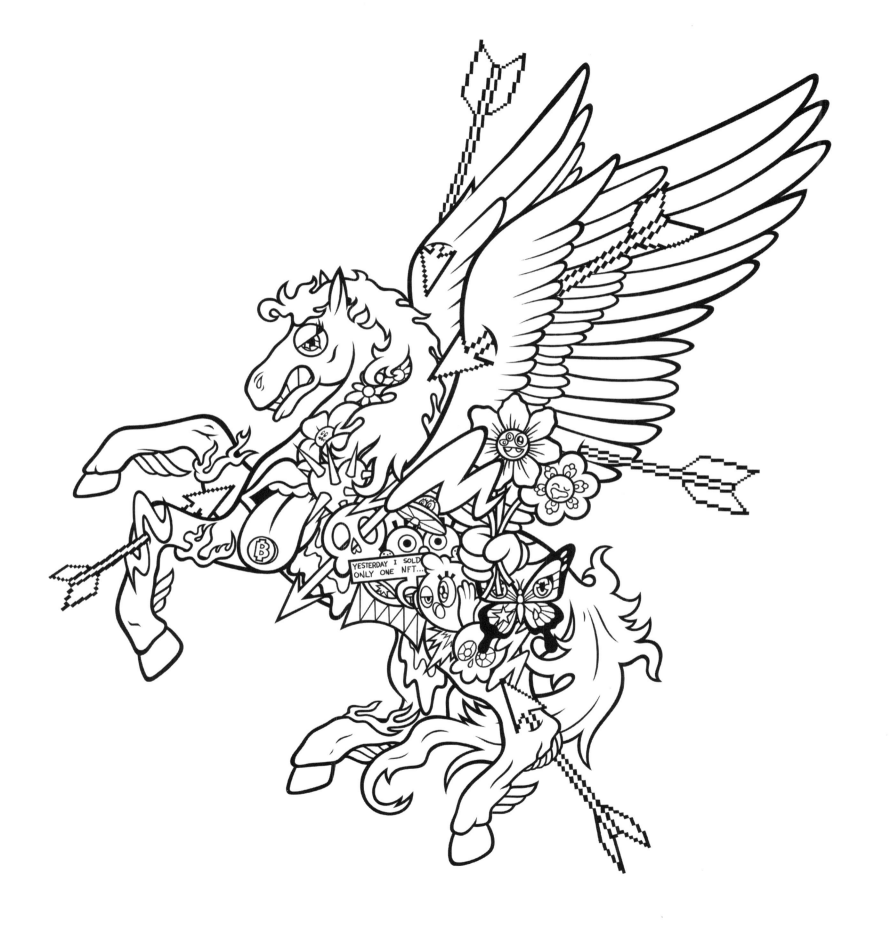

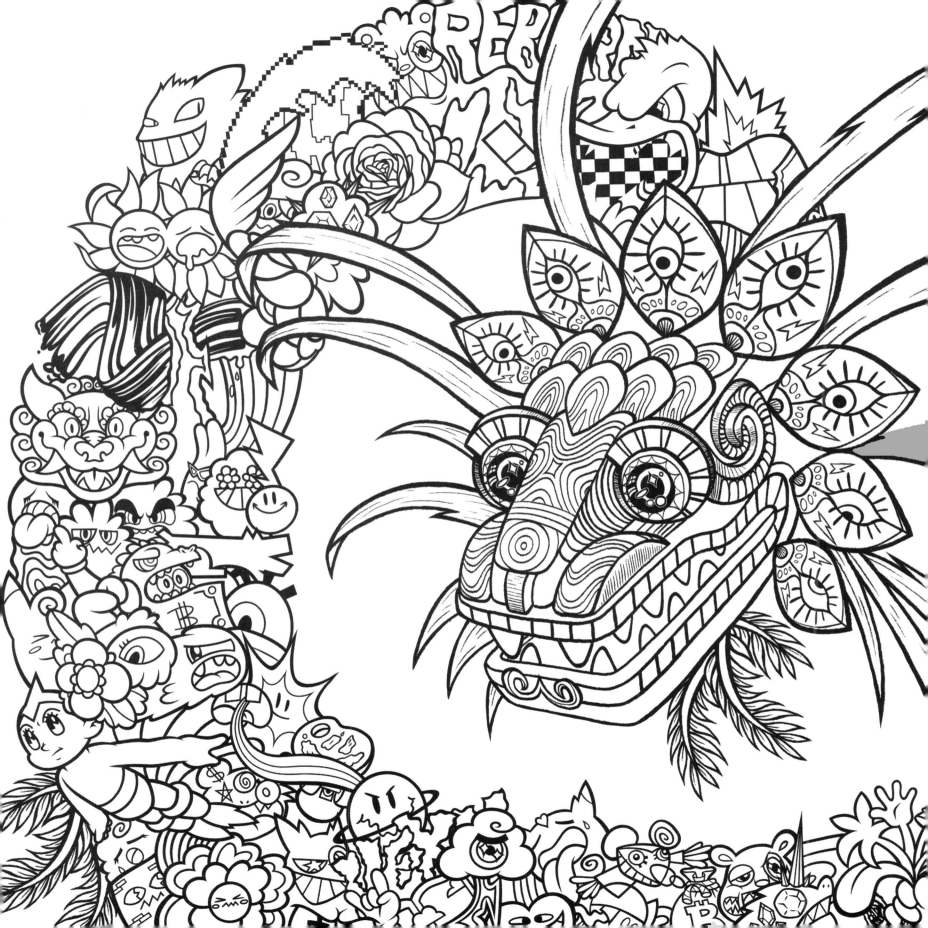

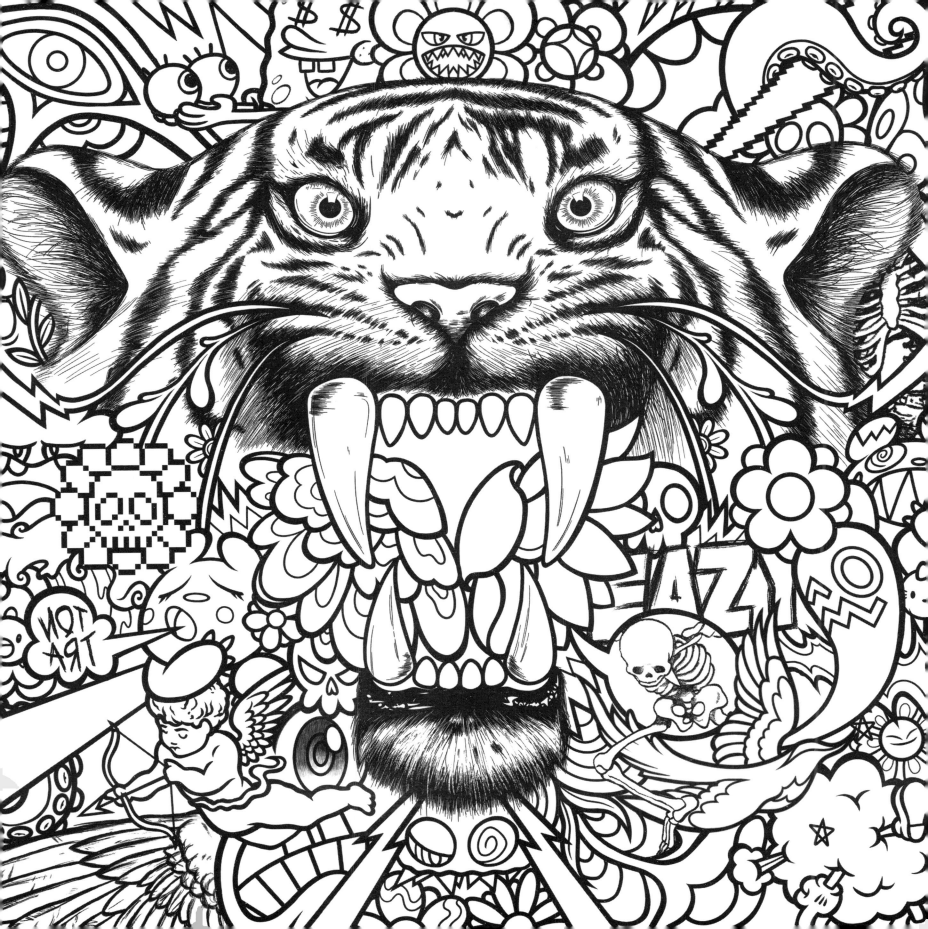

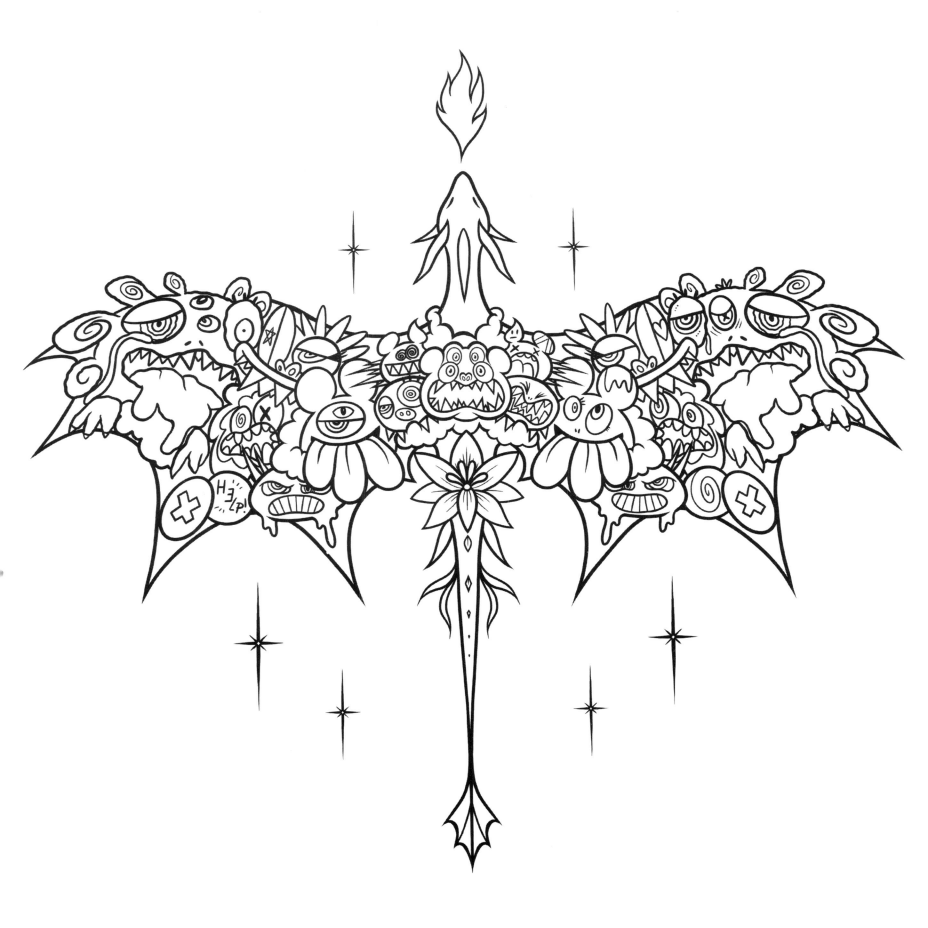

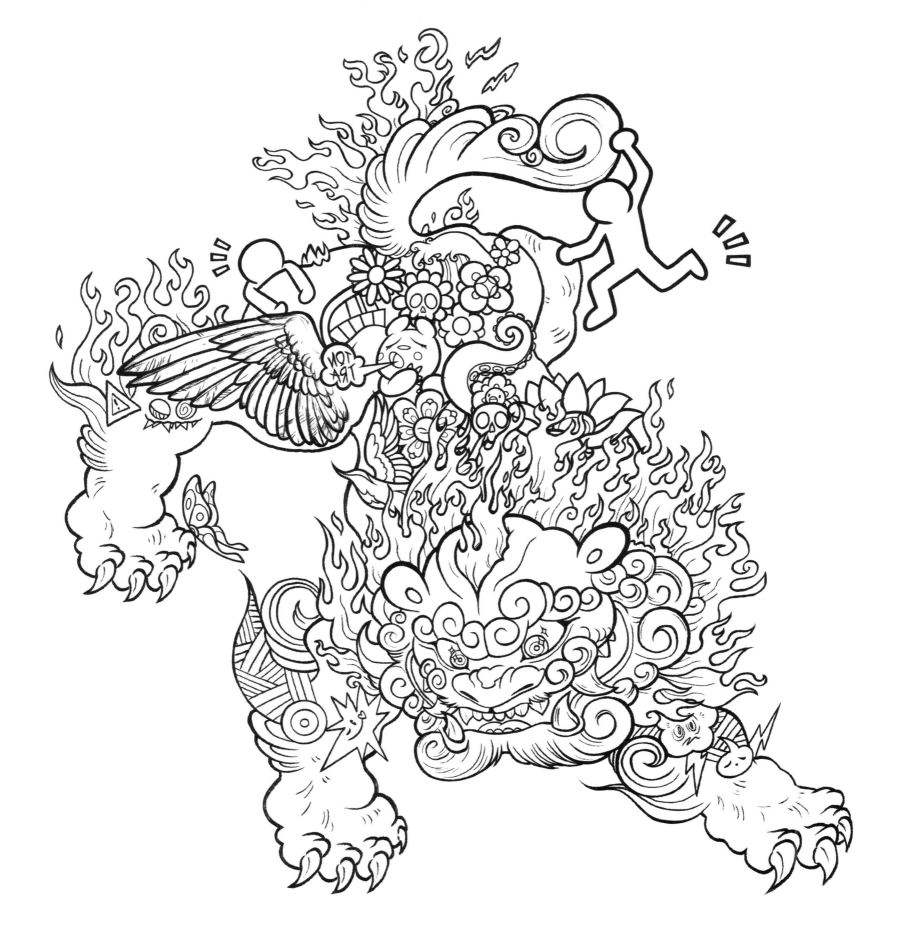

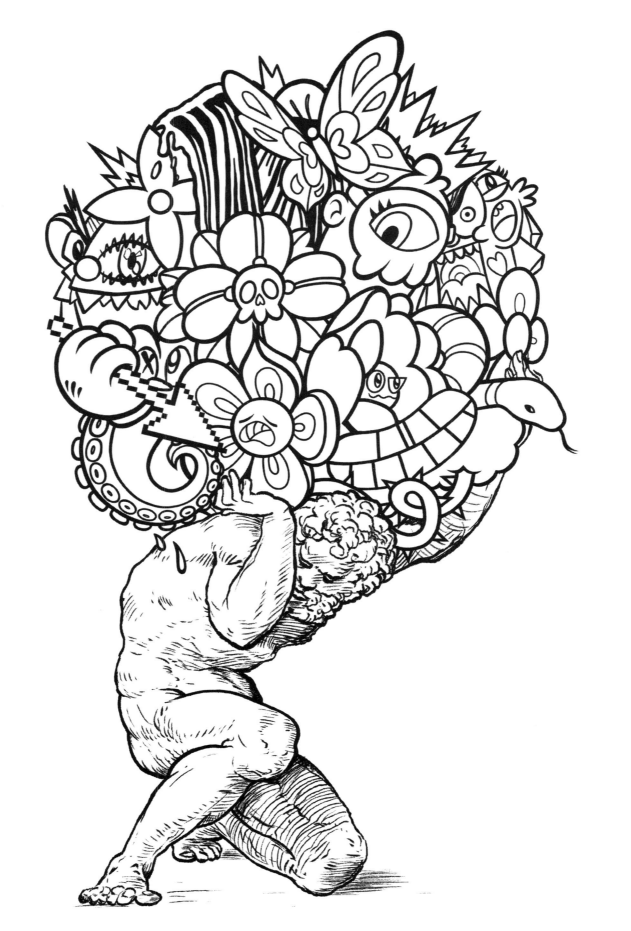

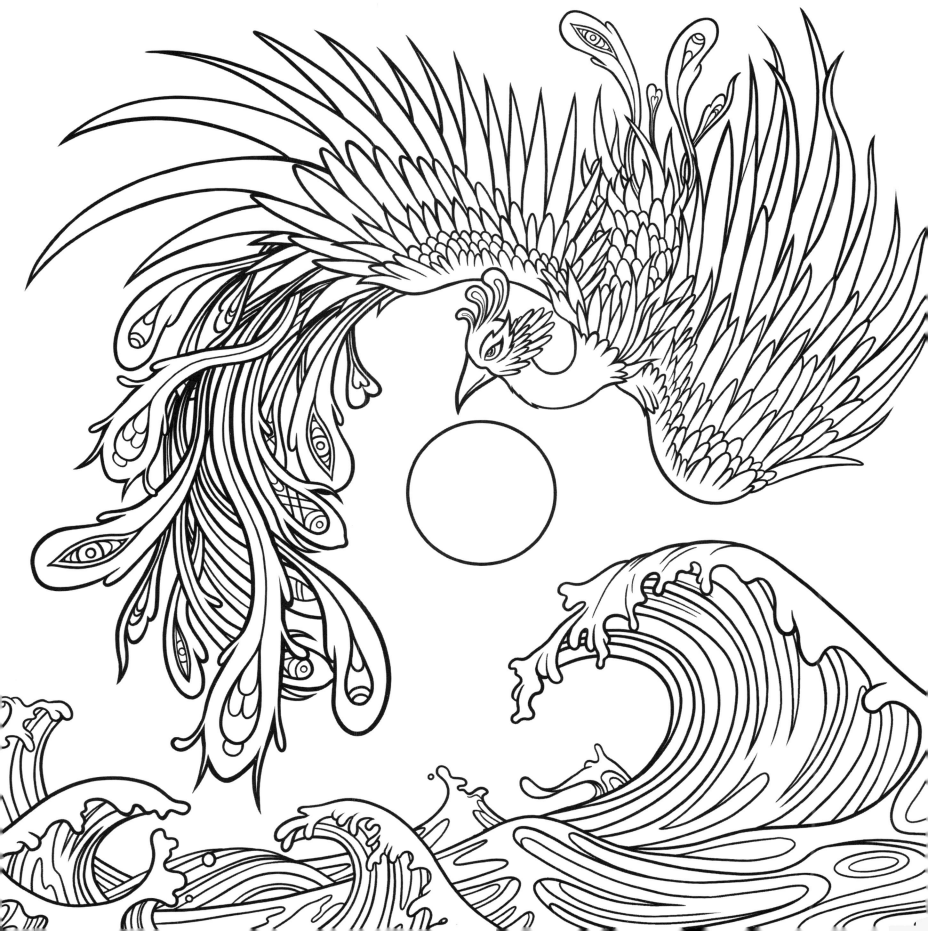

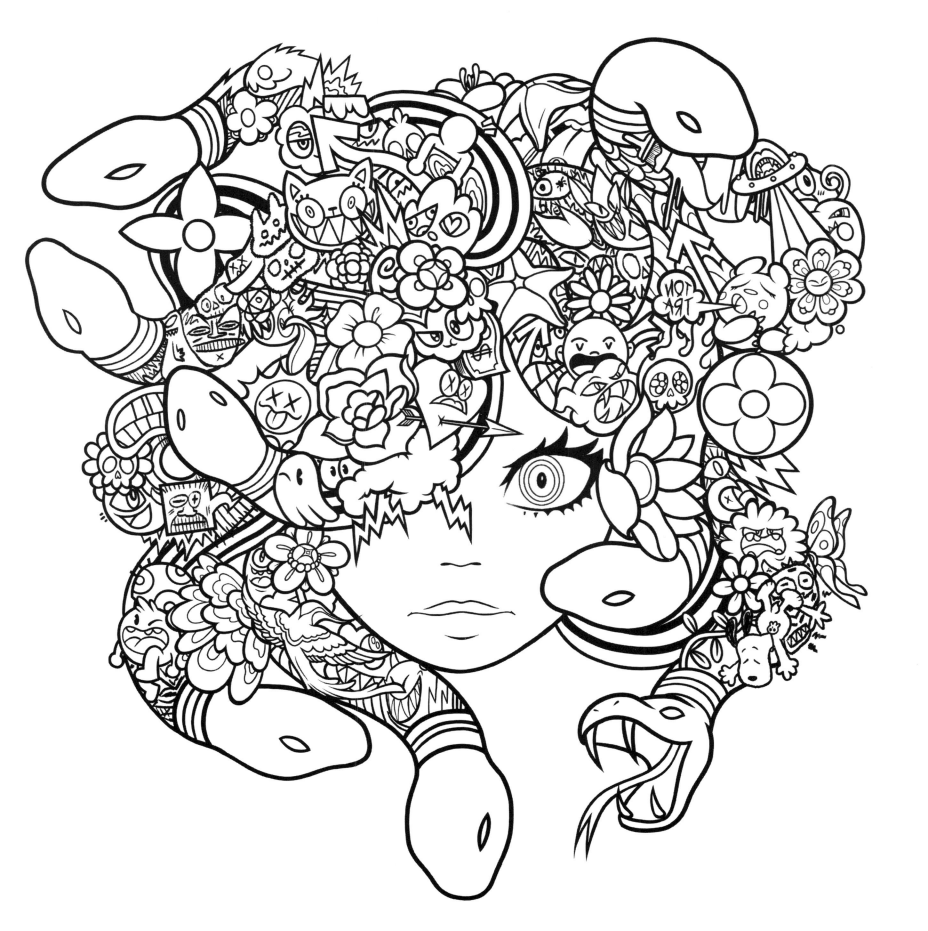

HYUNMOO BY DONG DONG

Dong Dong is an eighteen-year-old Korean art creator. He is interested in various fields such as art, film, fashion, and photography. He pursues harmony of colors and forms through design across the past, present, and future.
Instagram: @dongdong.art

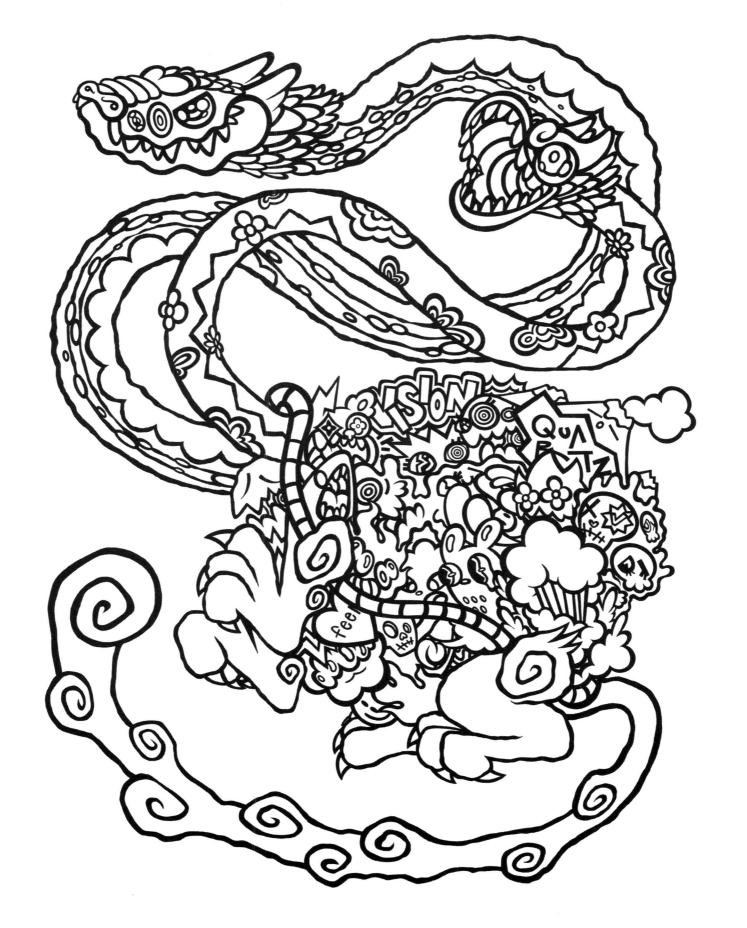

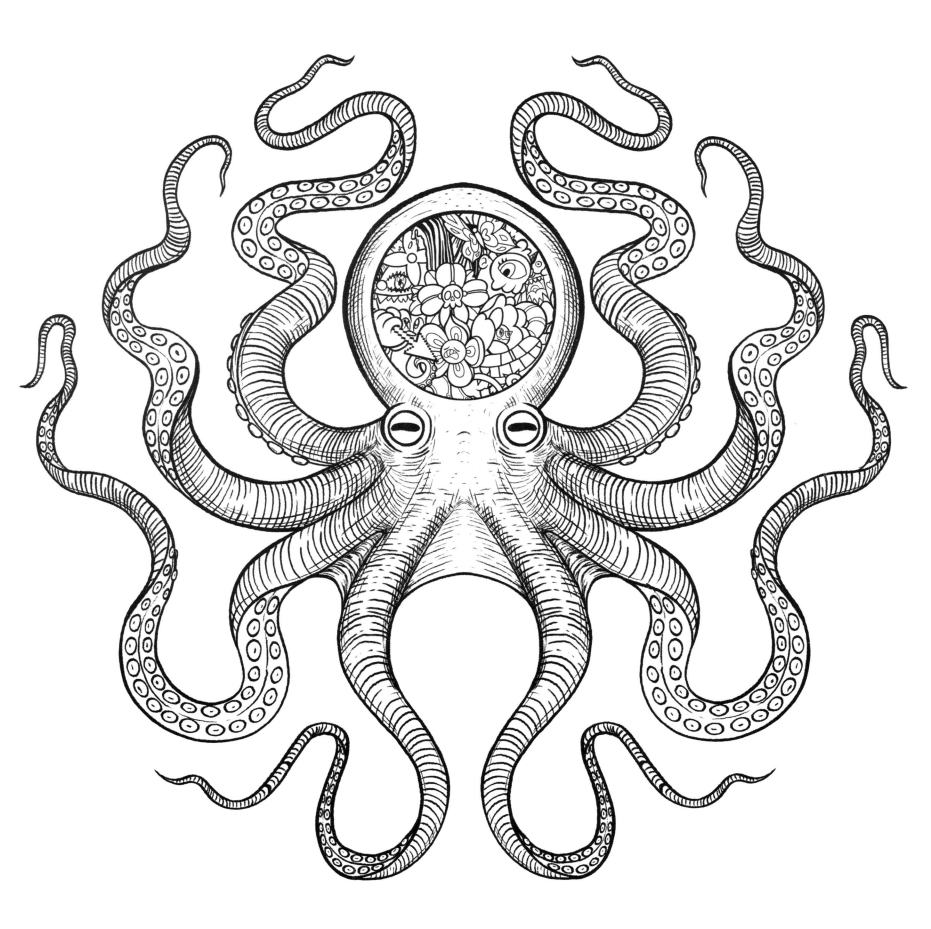

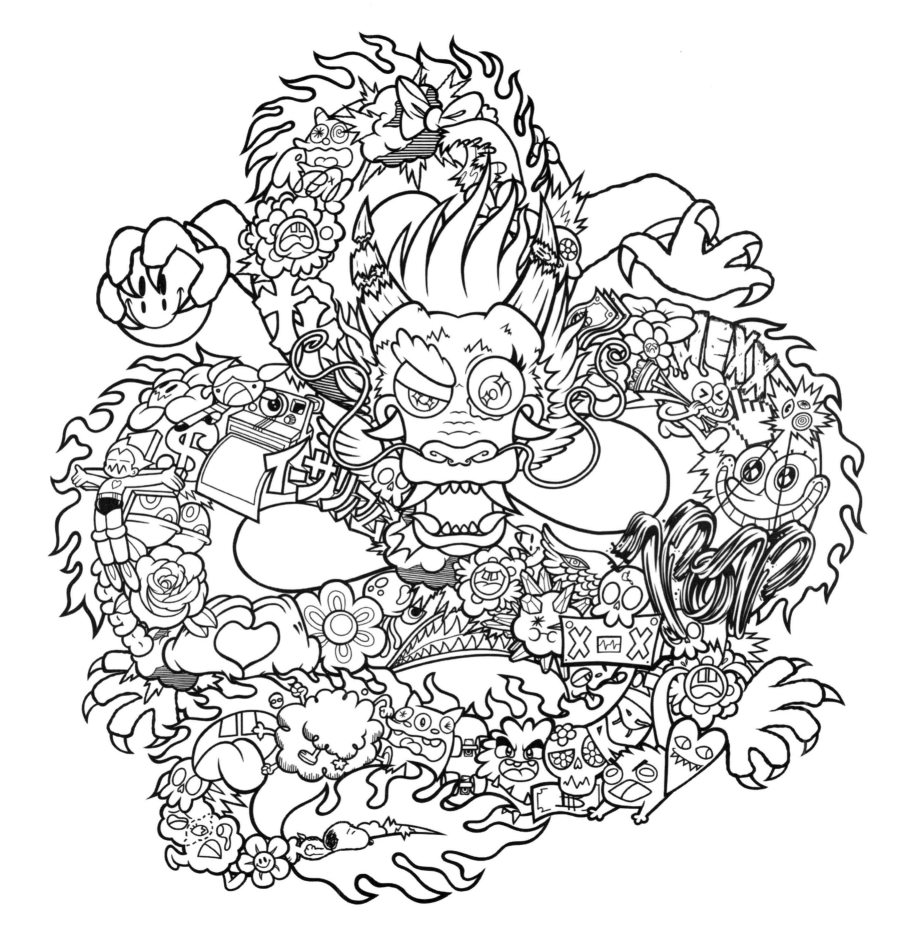

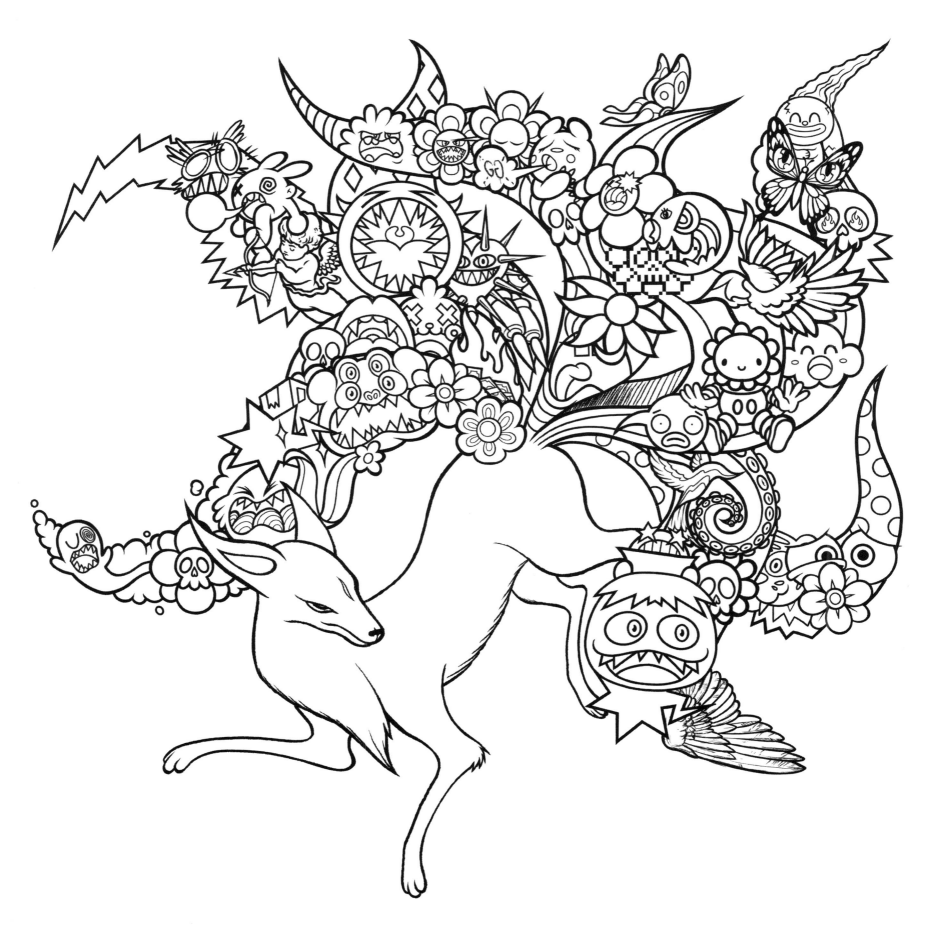

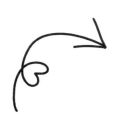

NAMAZU BY DOJEY

Dojey is a fifteen-year-old visual artist
residing in the UK. His art explores the
fusion of design and culture, past and
contemporary, constructing his own
world, close but far from reality.
Instagram: @dojey.art

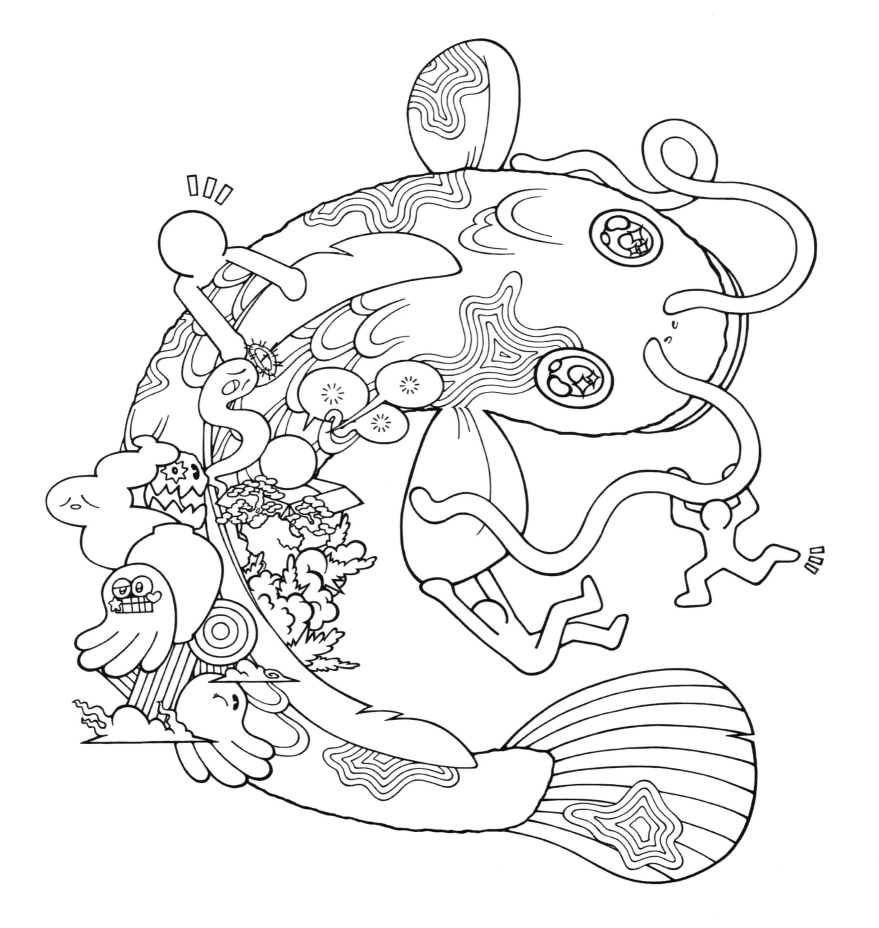

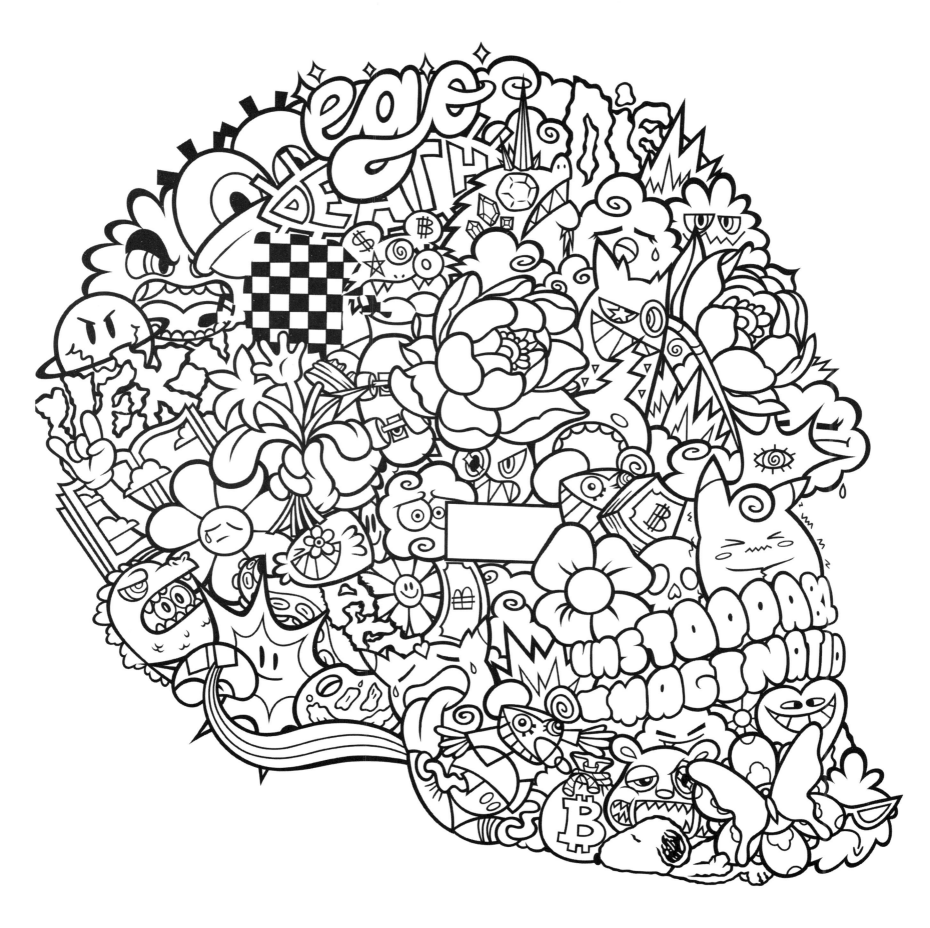

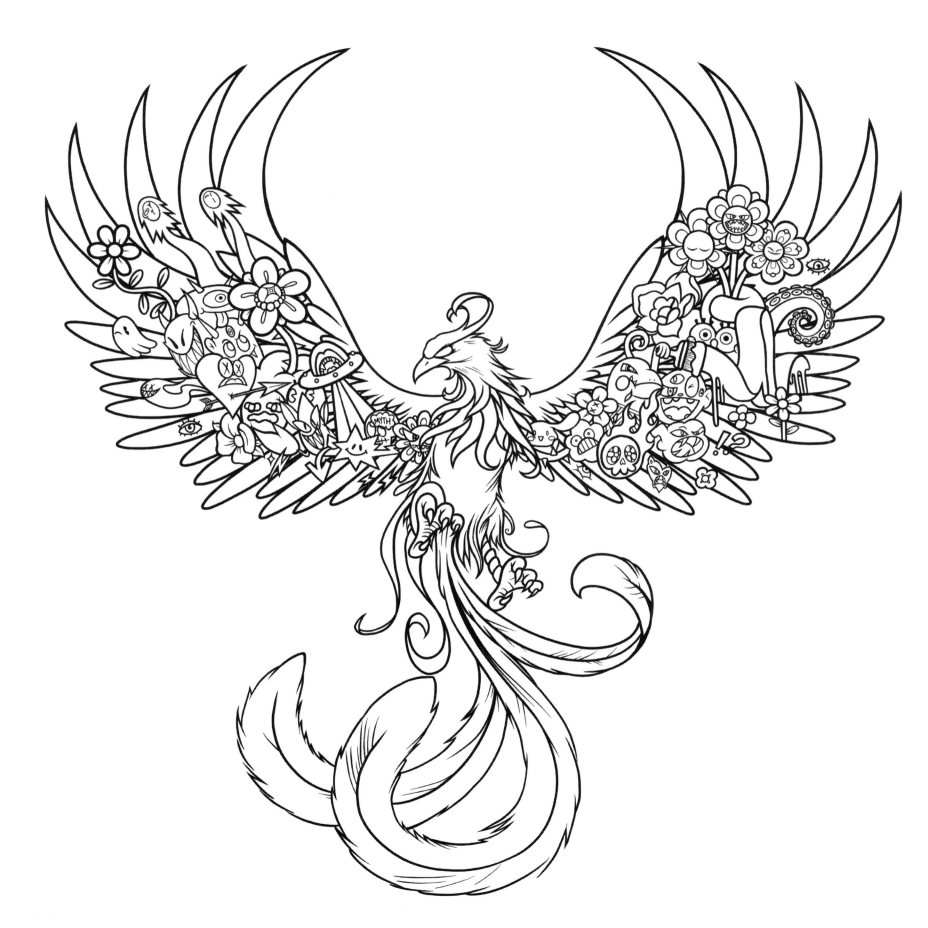

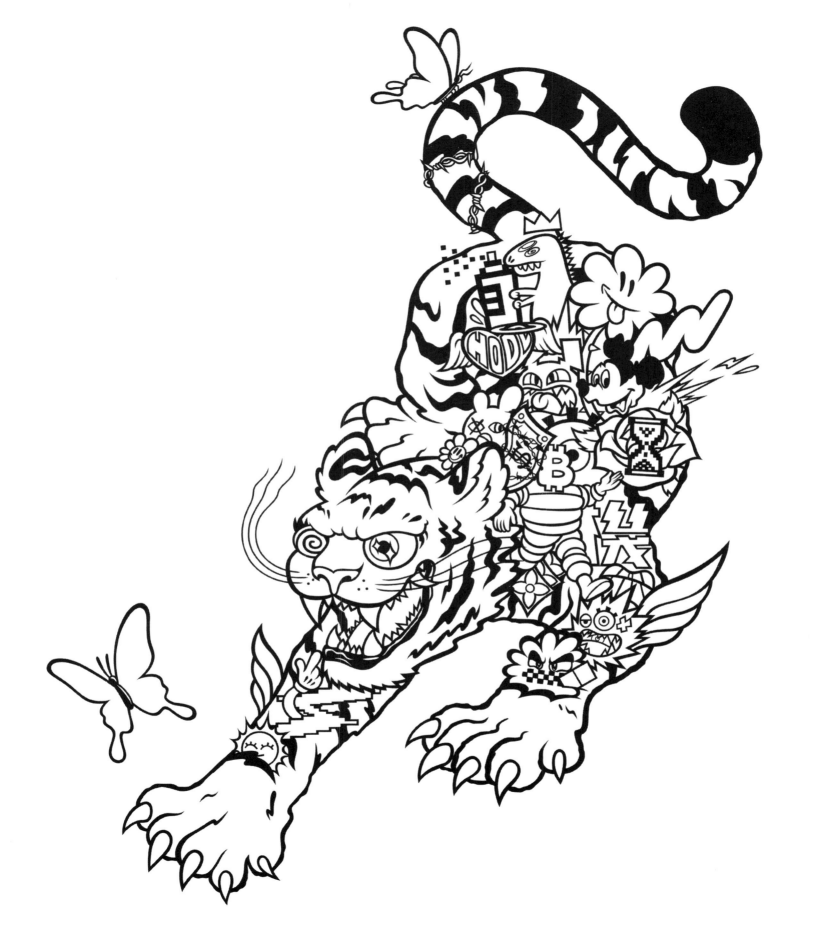

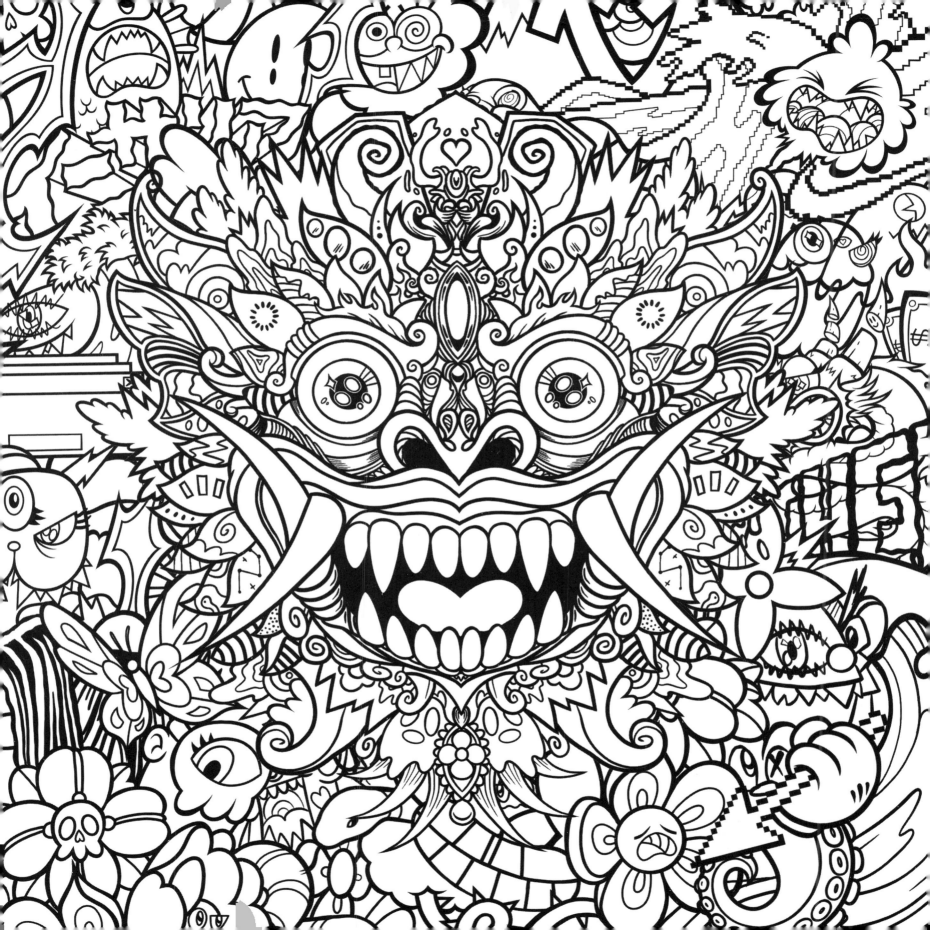

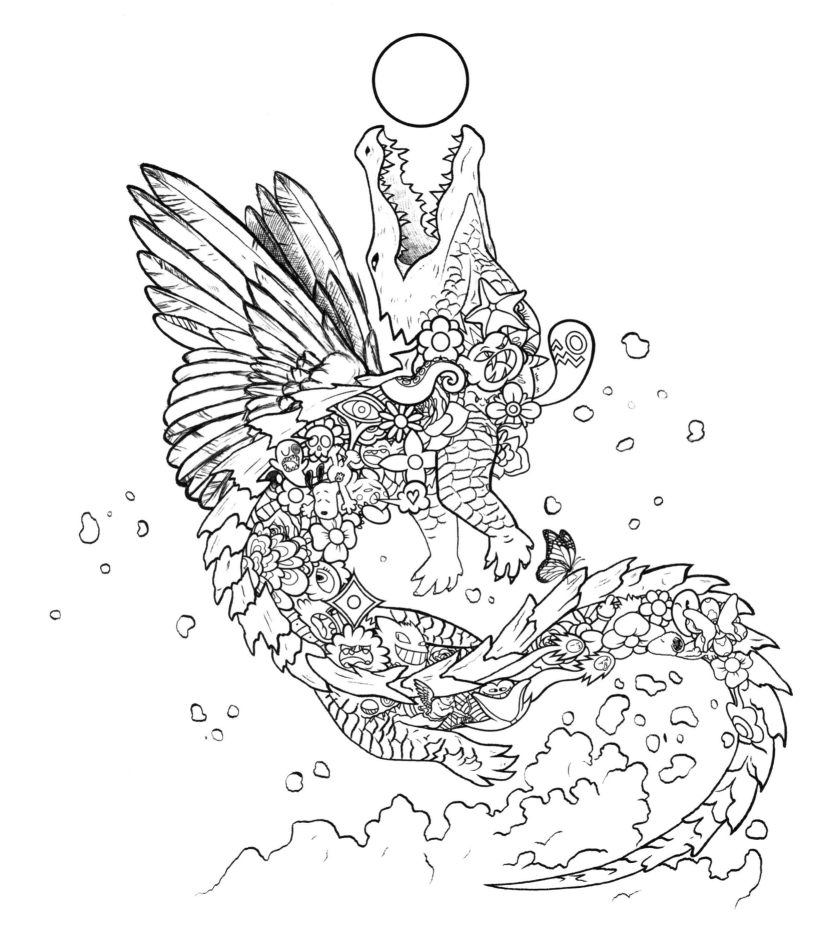

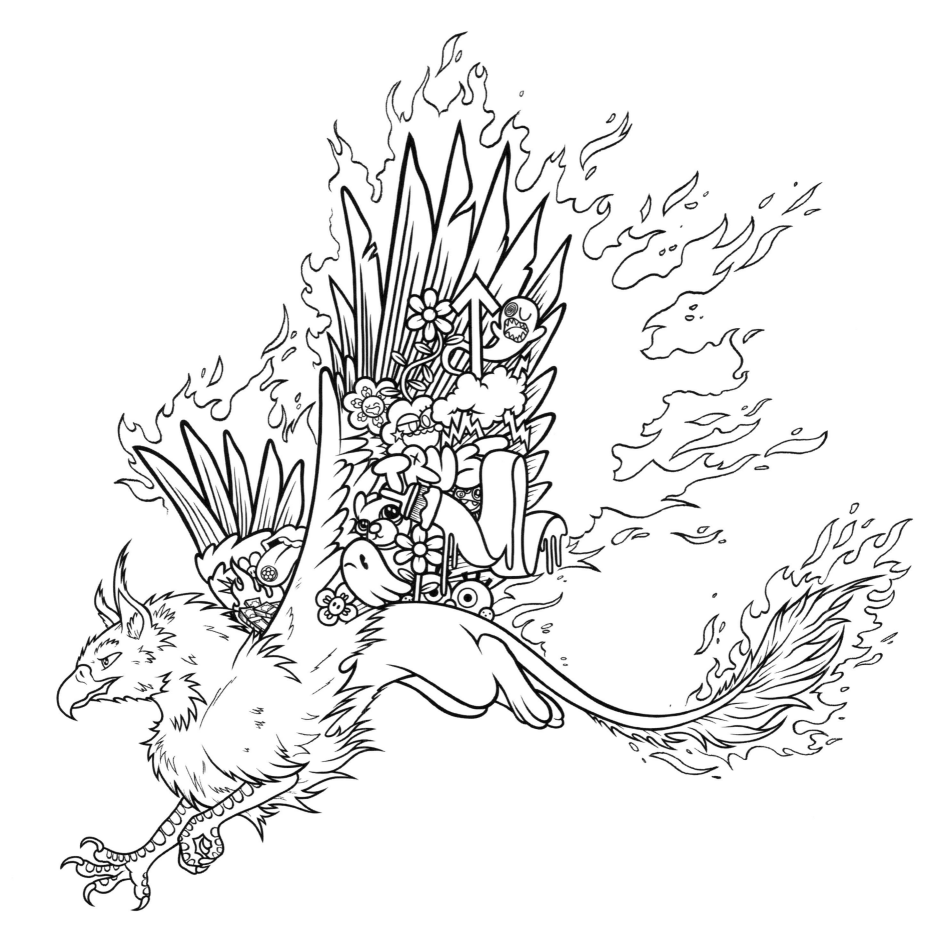

CHIMERA BY BENJII
Benjii is a "visual experimentalist."
He is eighteen and currently living
in Canada. His favorite colors are
neon yellow, hot pink, and sky blue.
Instagram: @benjii.art

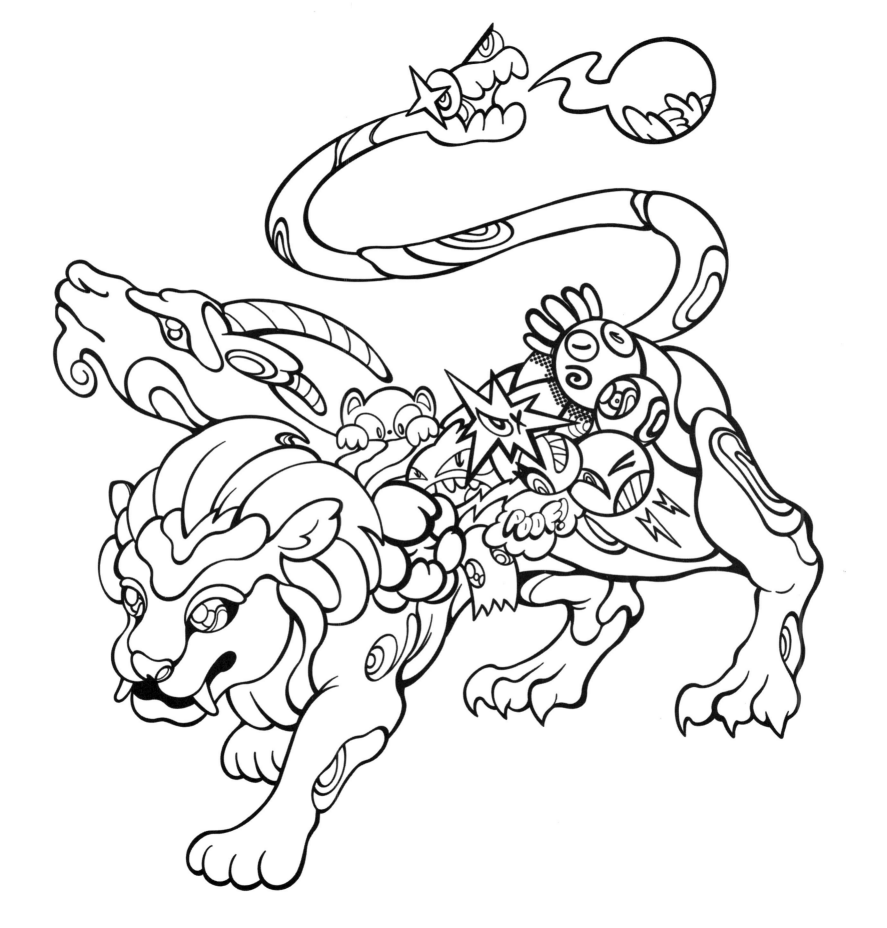

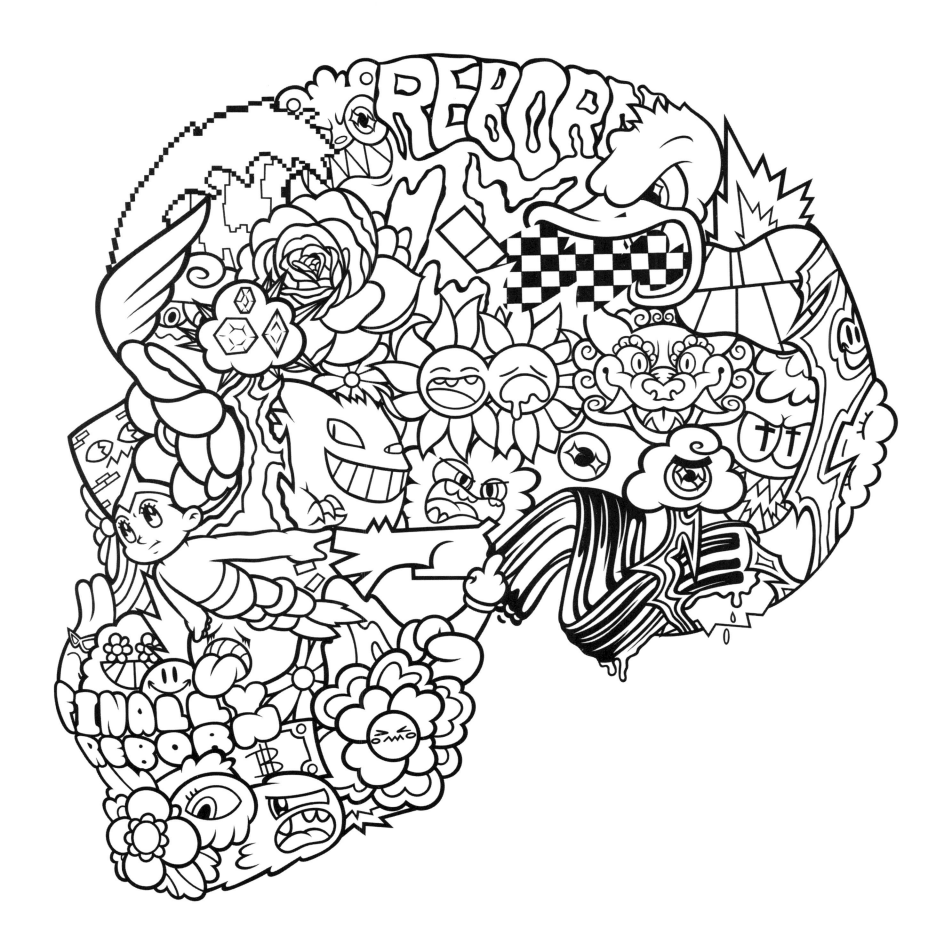

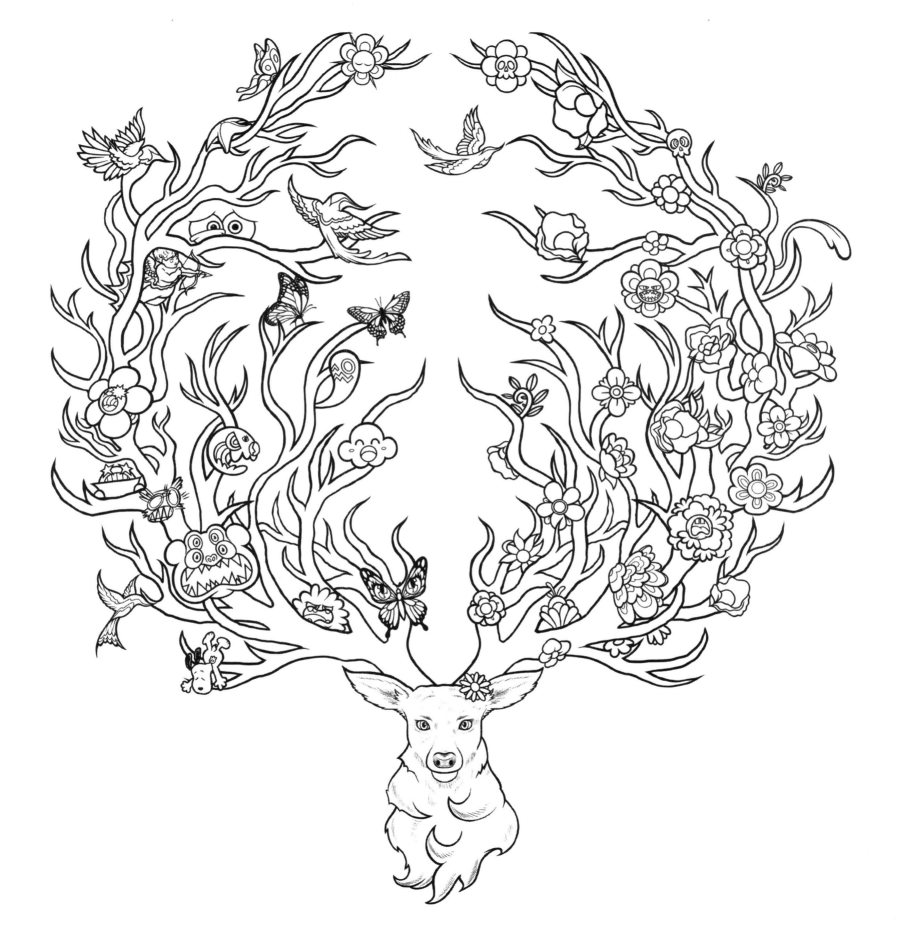

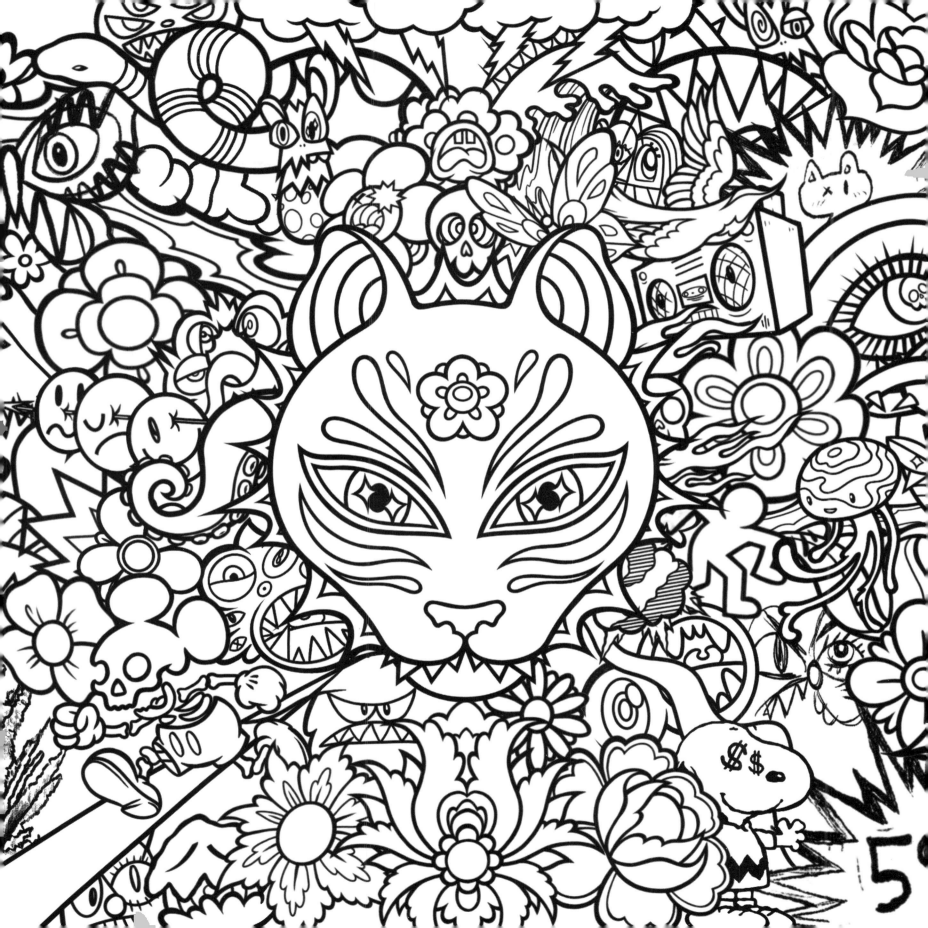

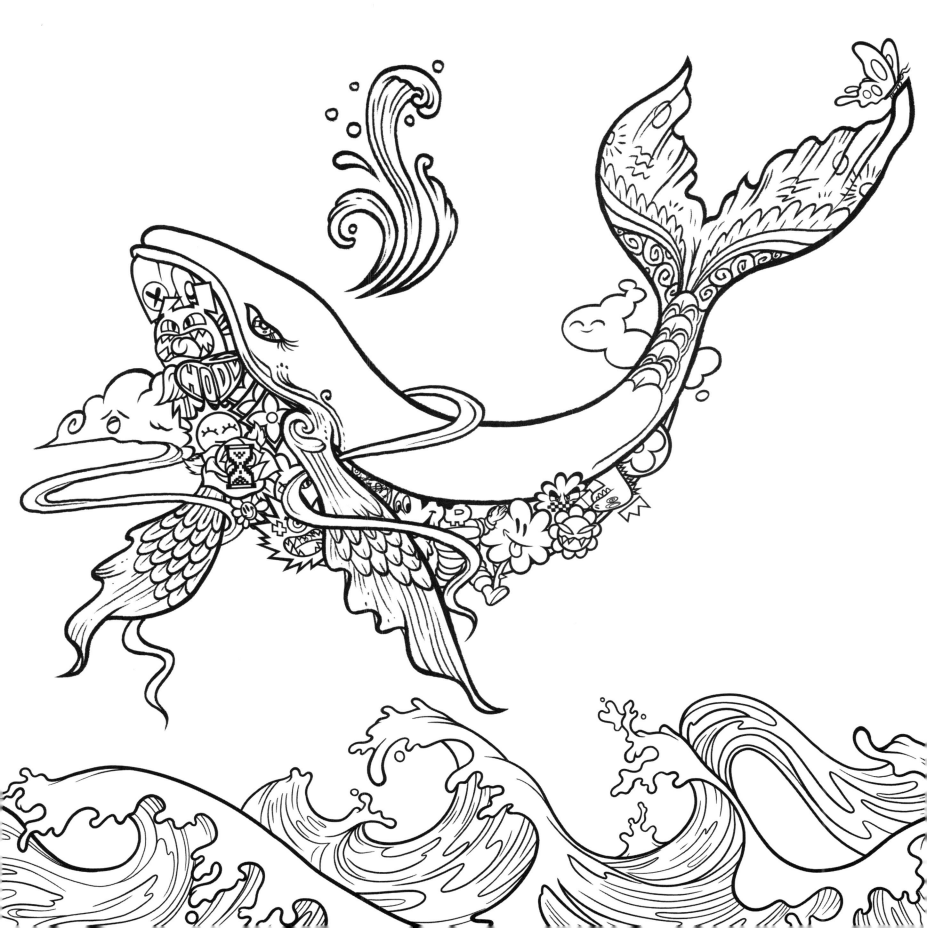

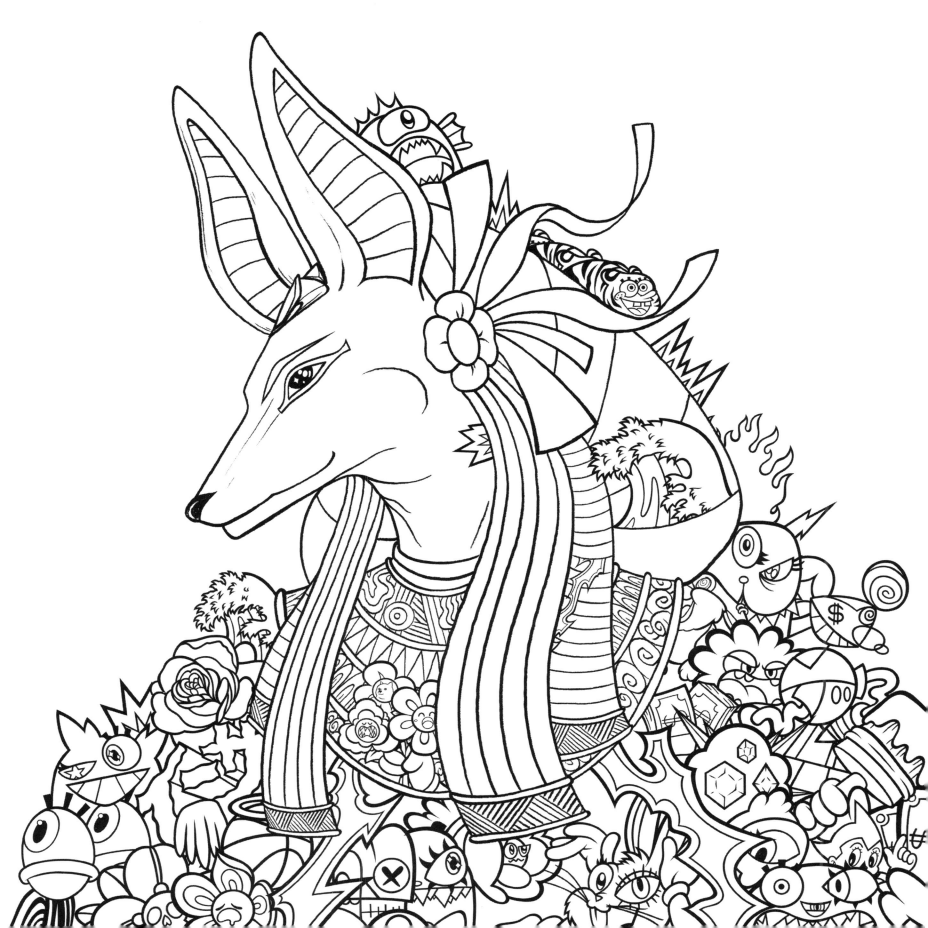

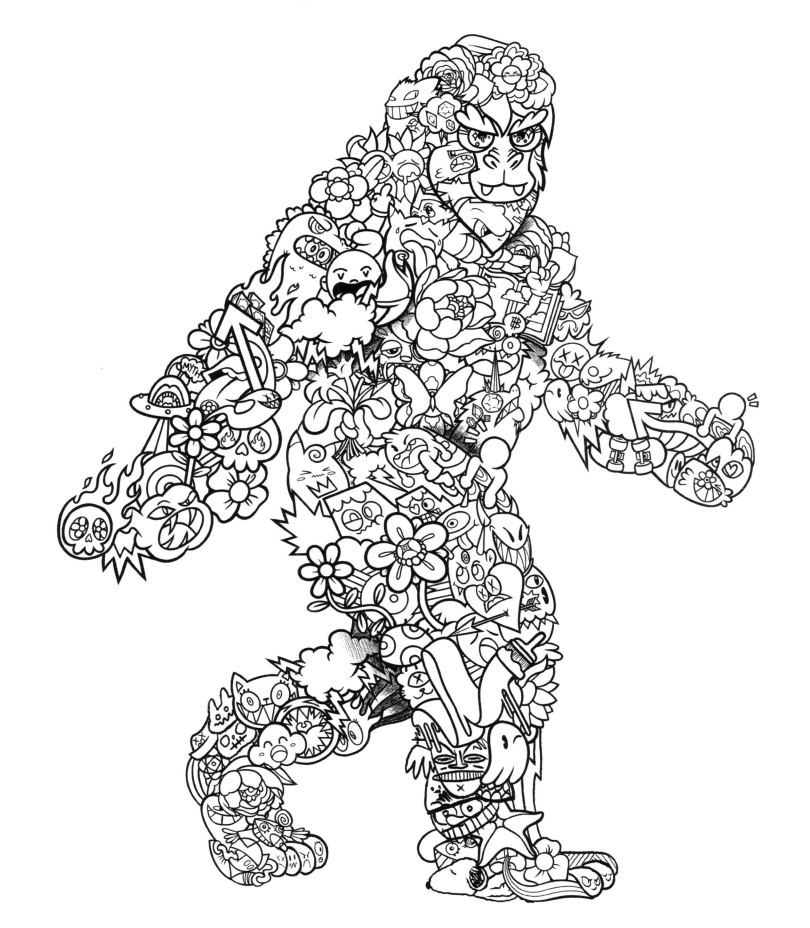

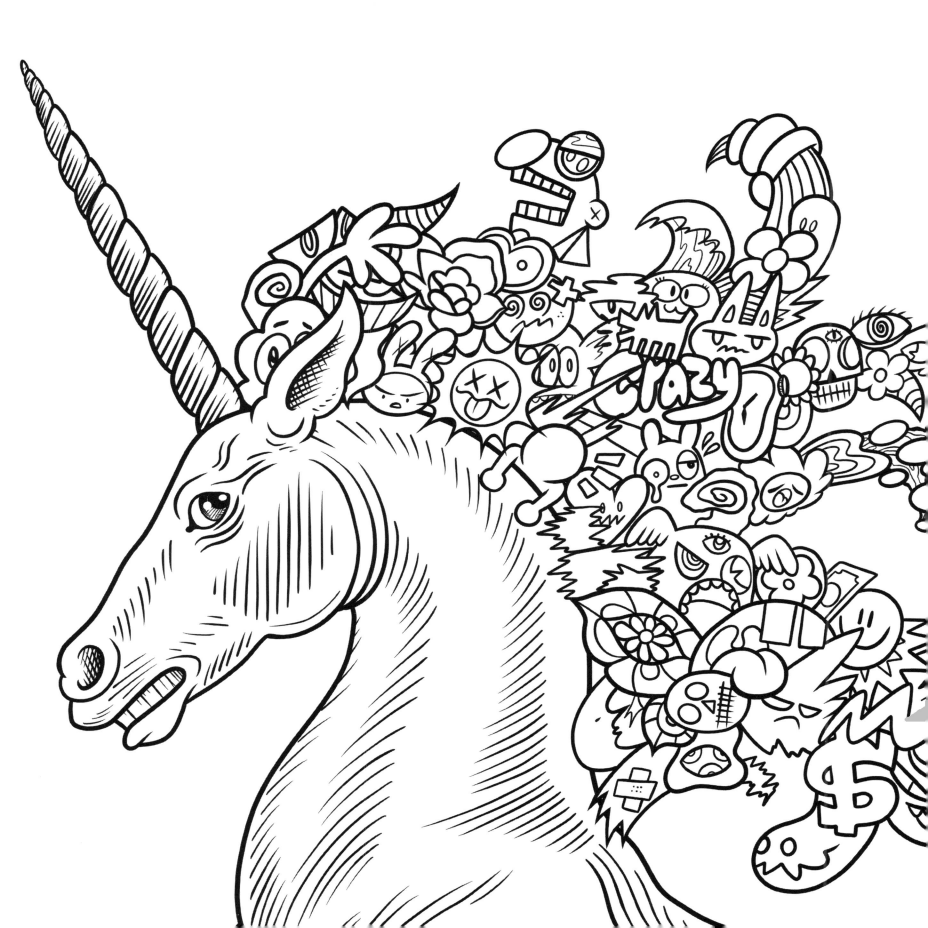

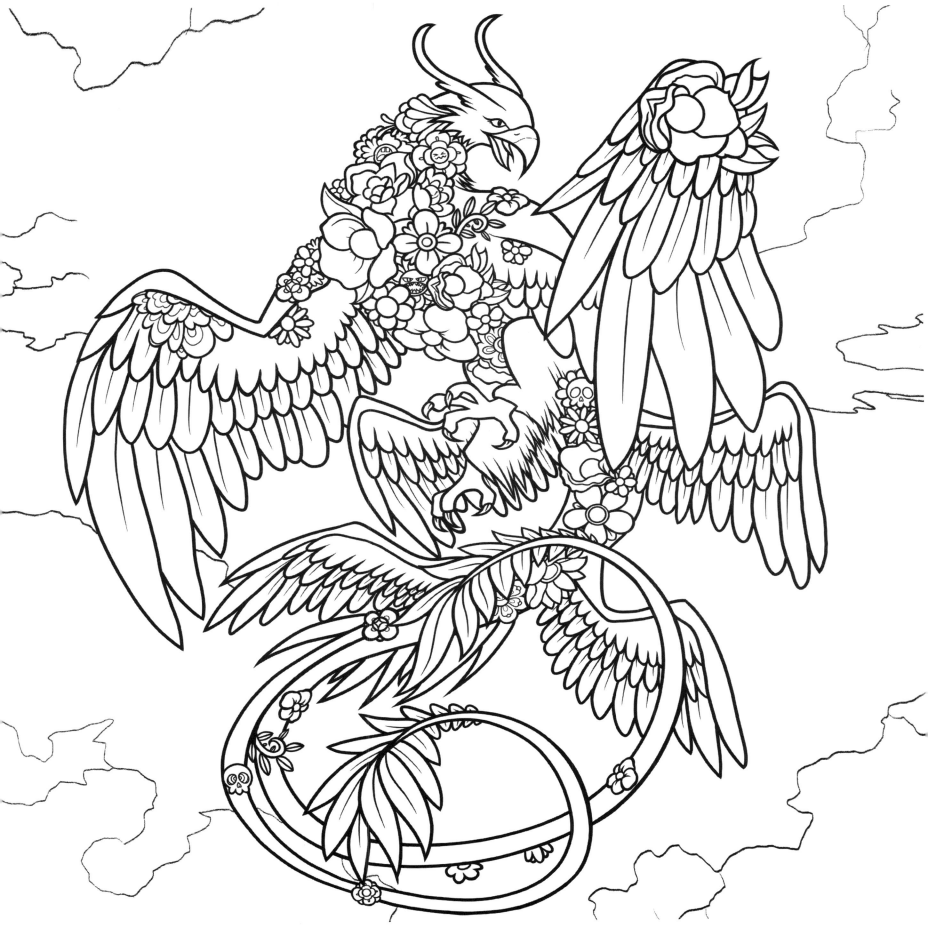

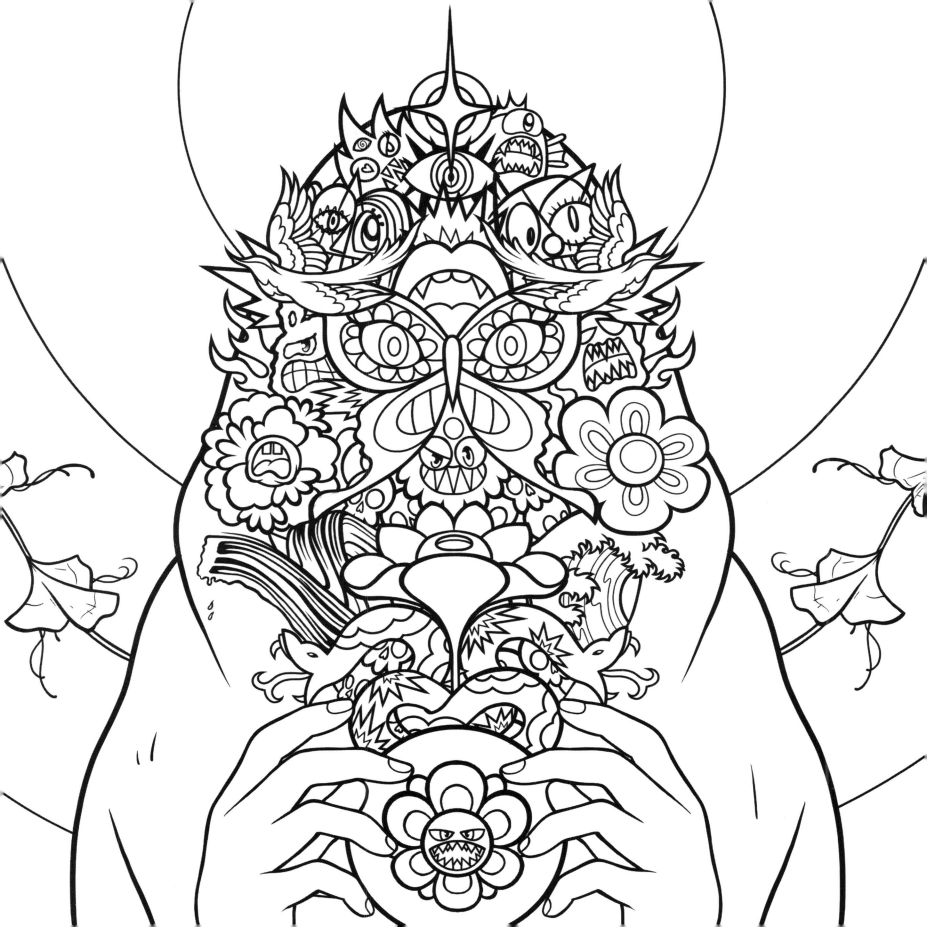

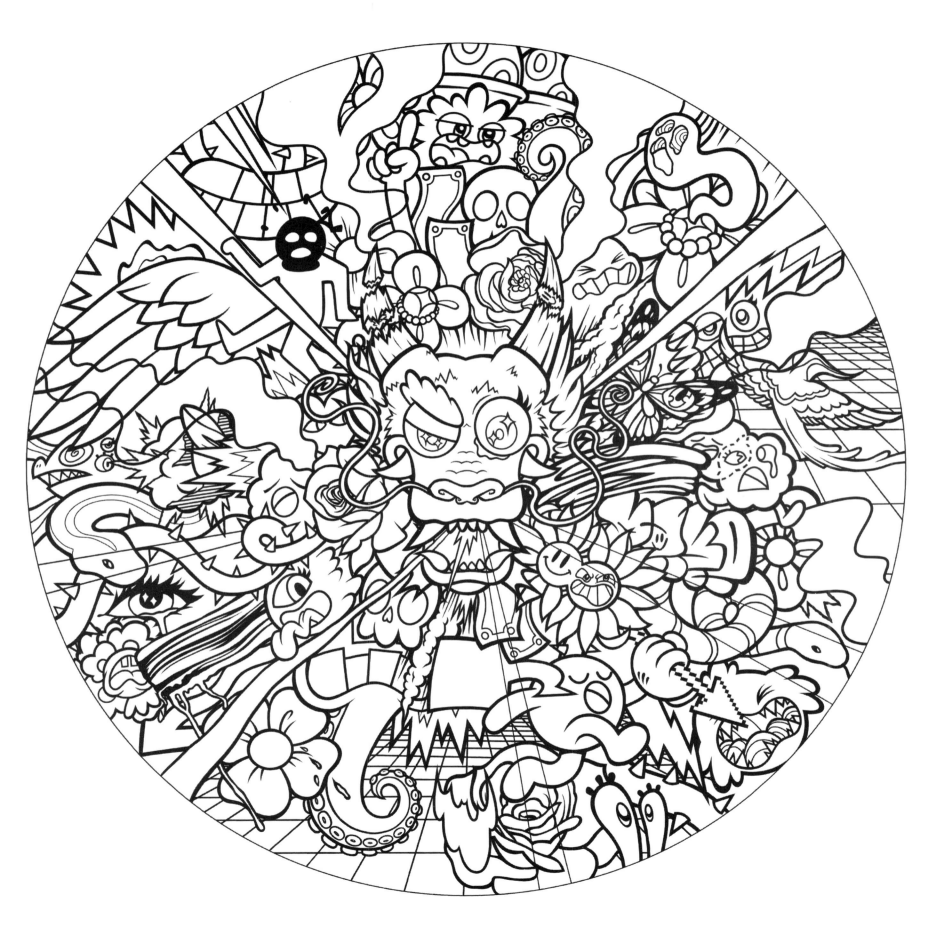

HAETAE BY DONG DONG

Dong Dong is an eighteen-year-old Korean
art creator. He is interested in various fields
such as art, film, fashion, and photography. He
pursues harmony of colors and forms through
design across the past, present, and future.
Instagram: @dongdong.art

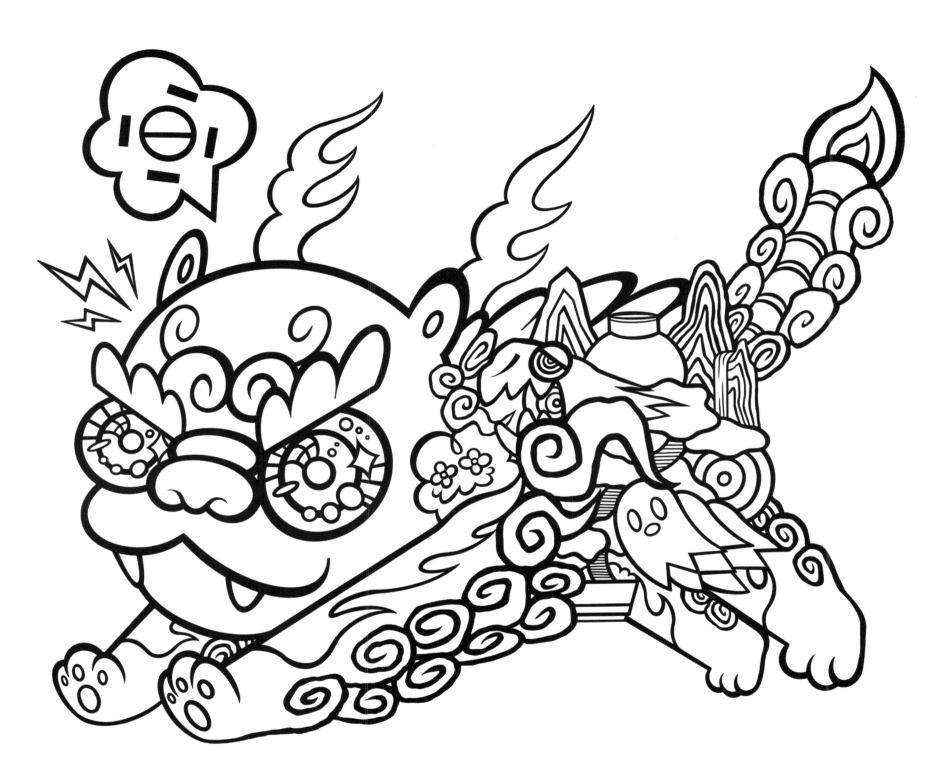

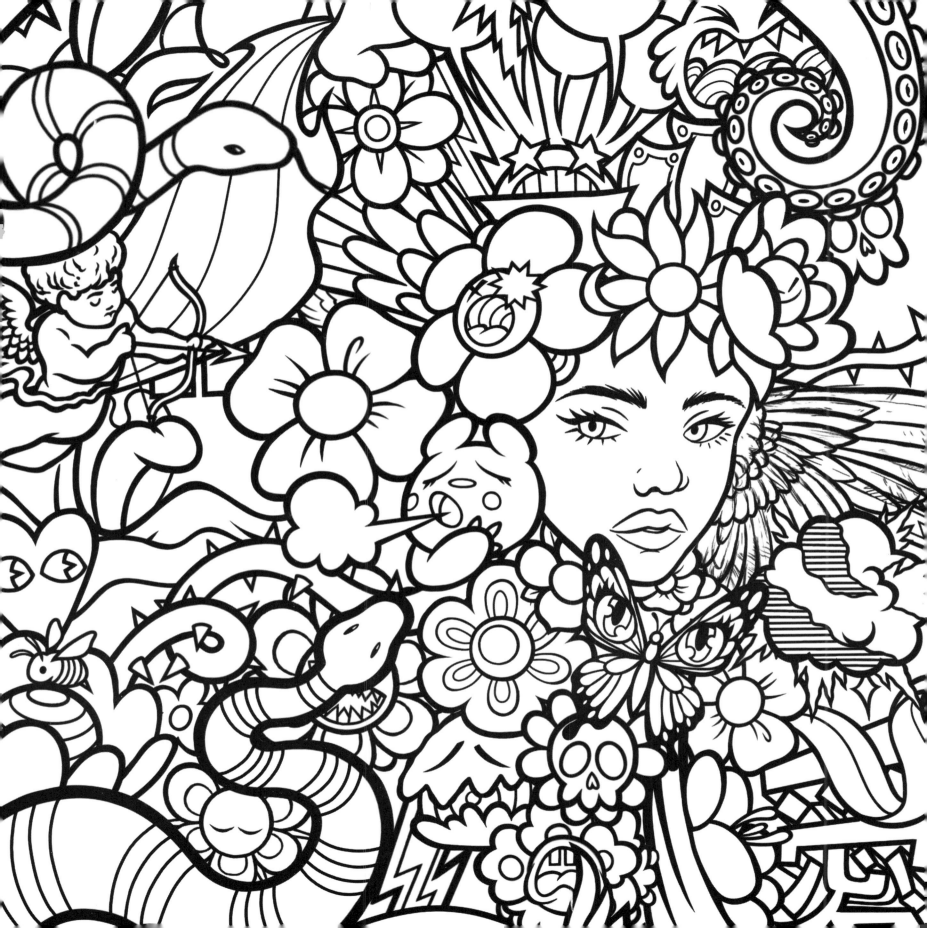

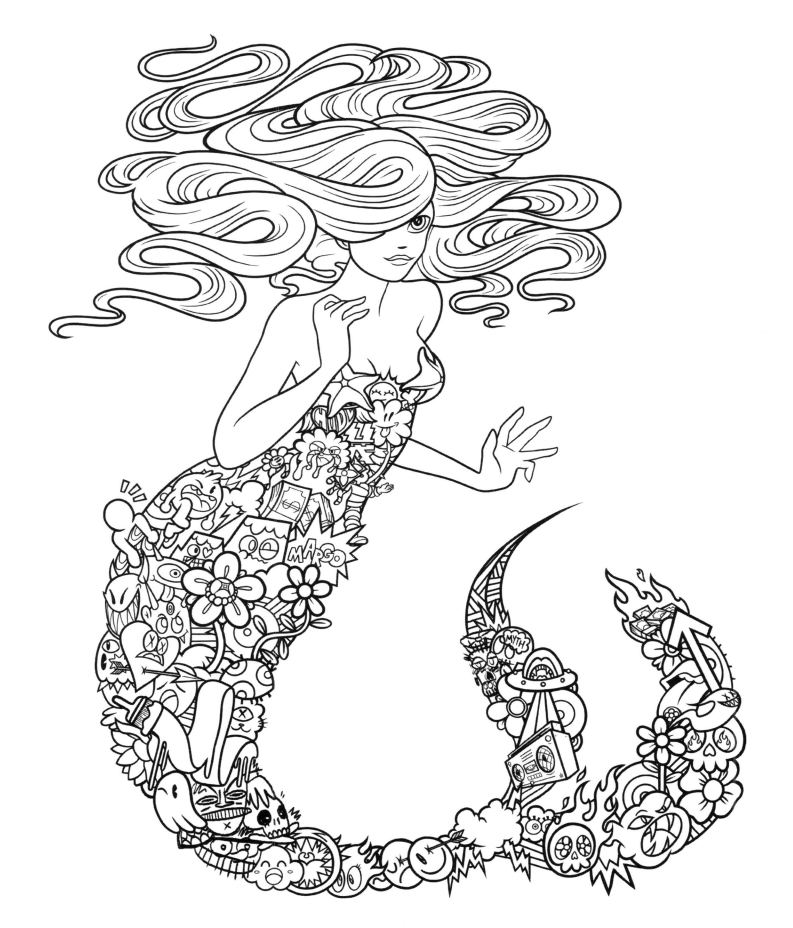

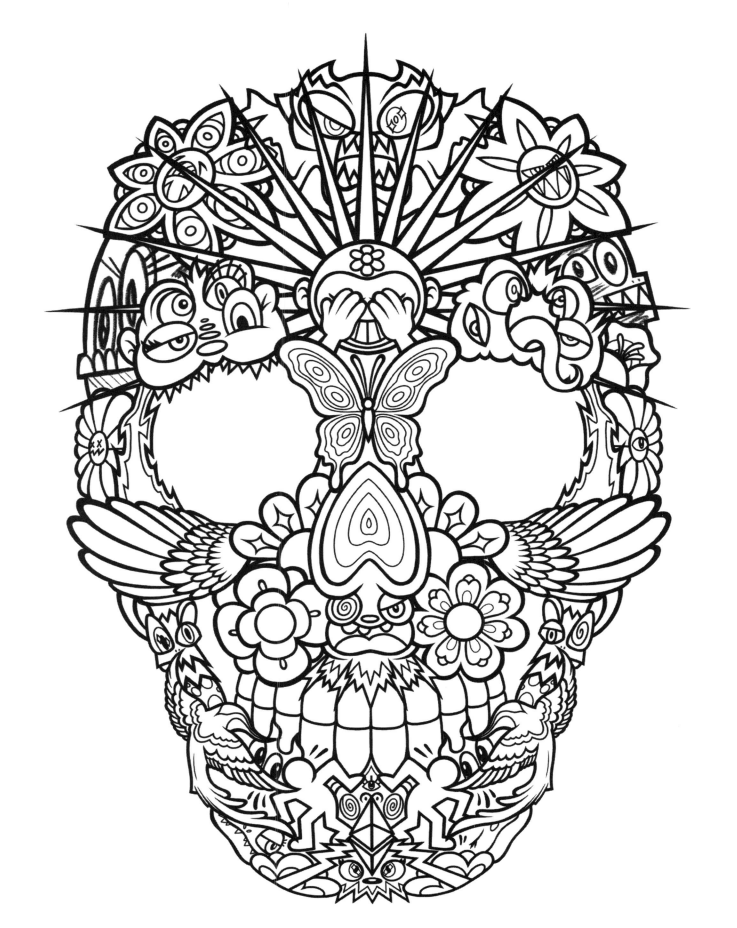

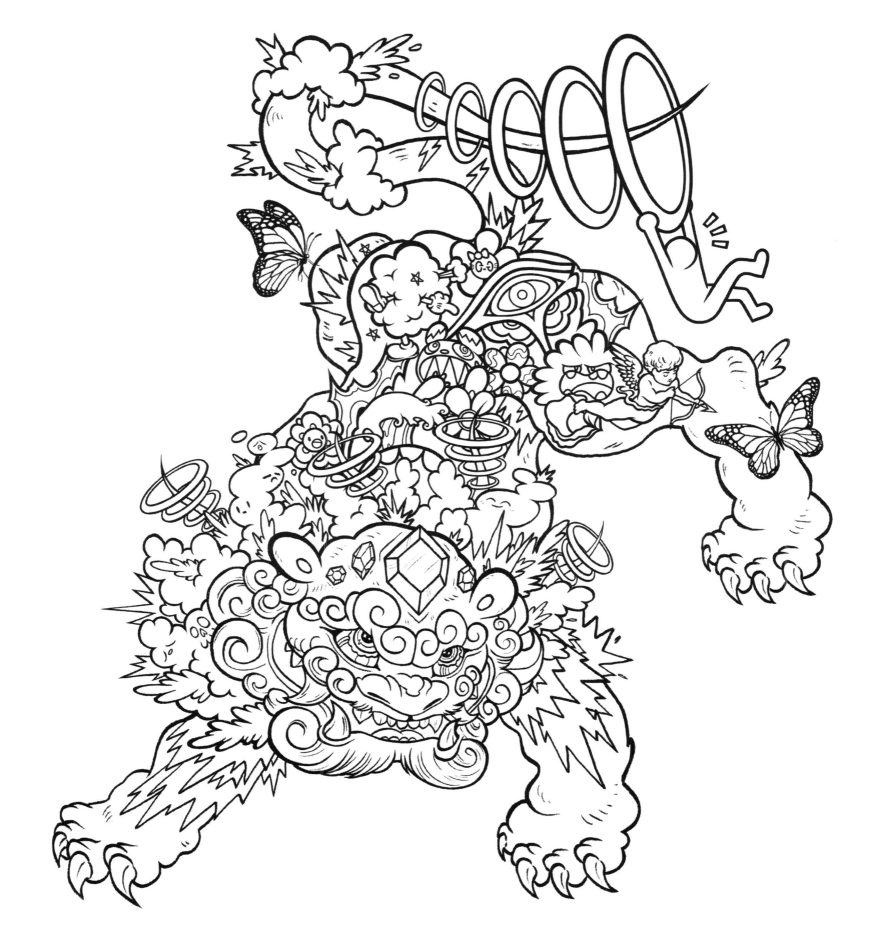

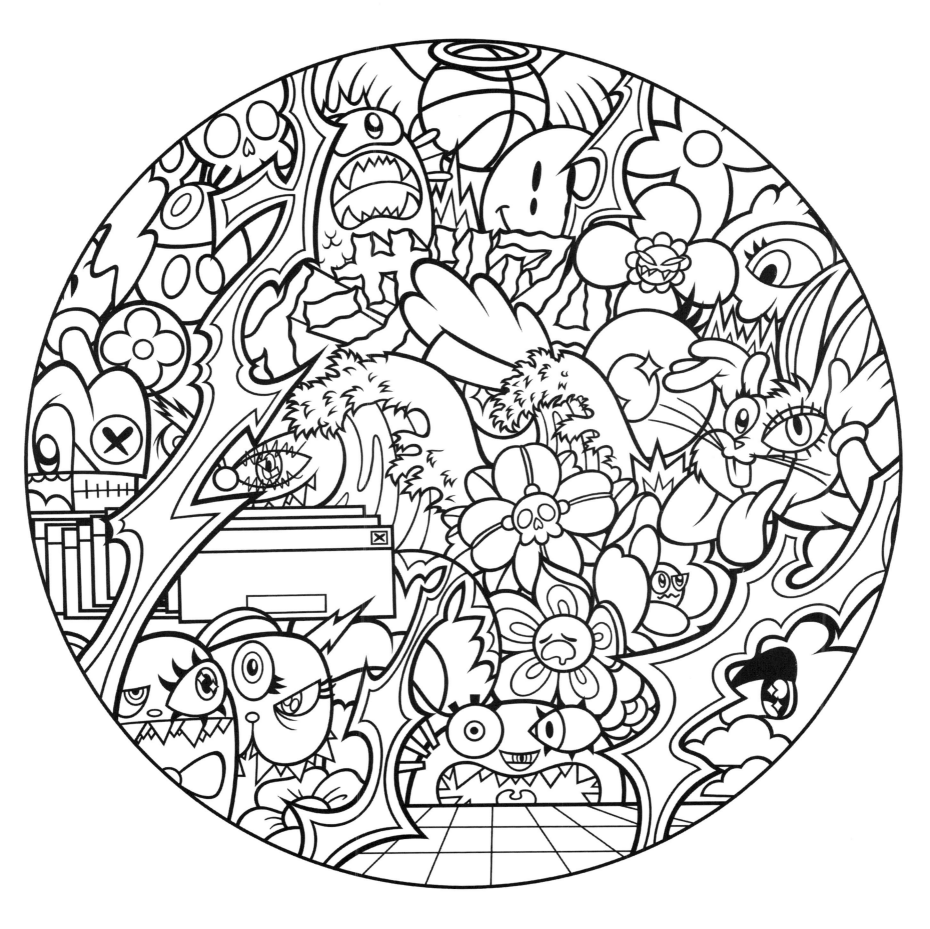

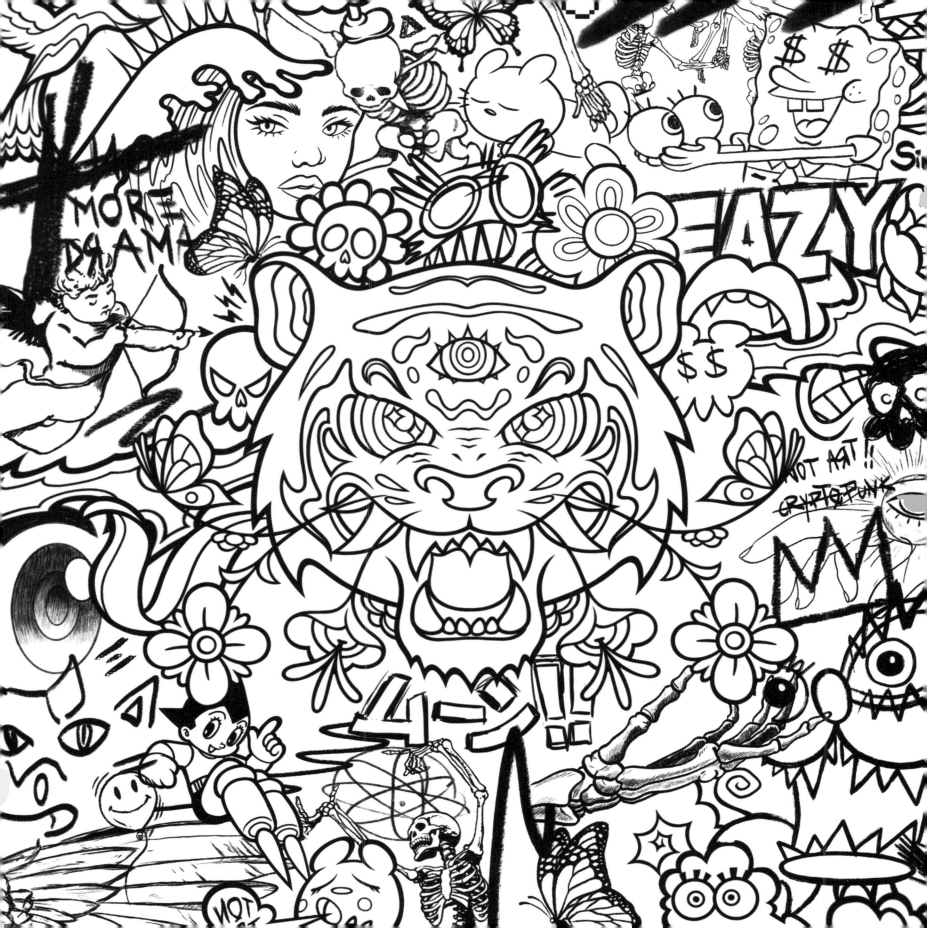

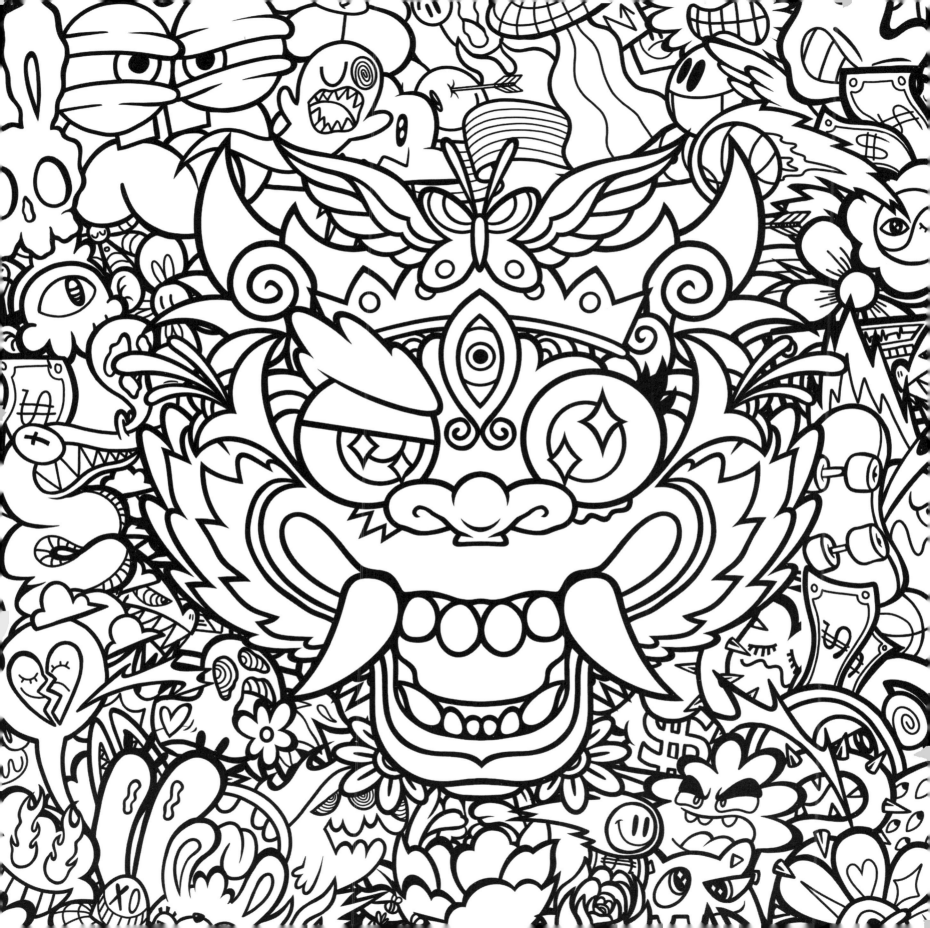

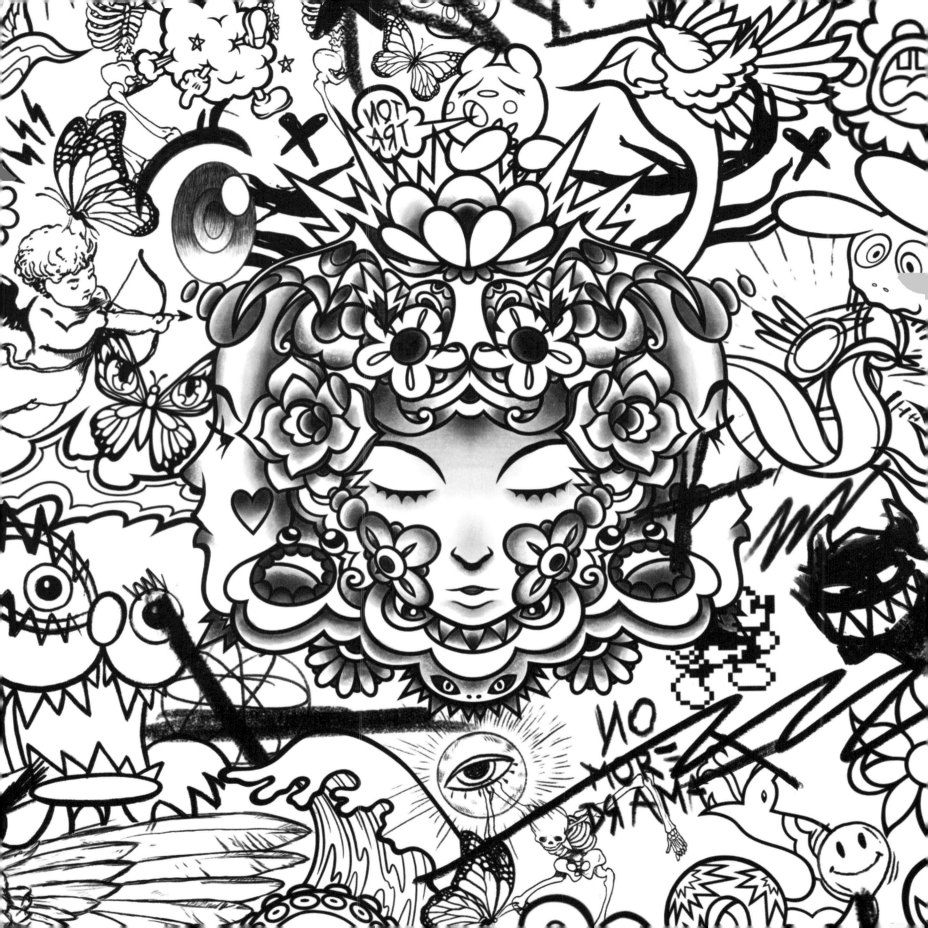

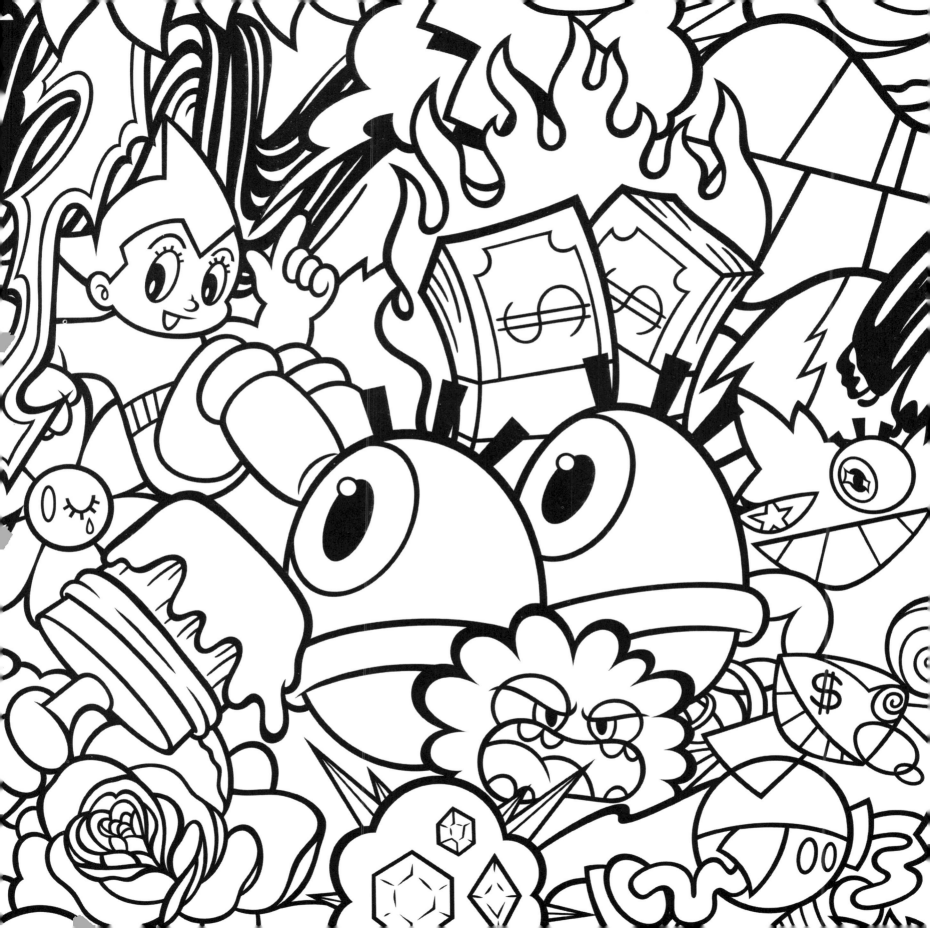

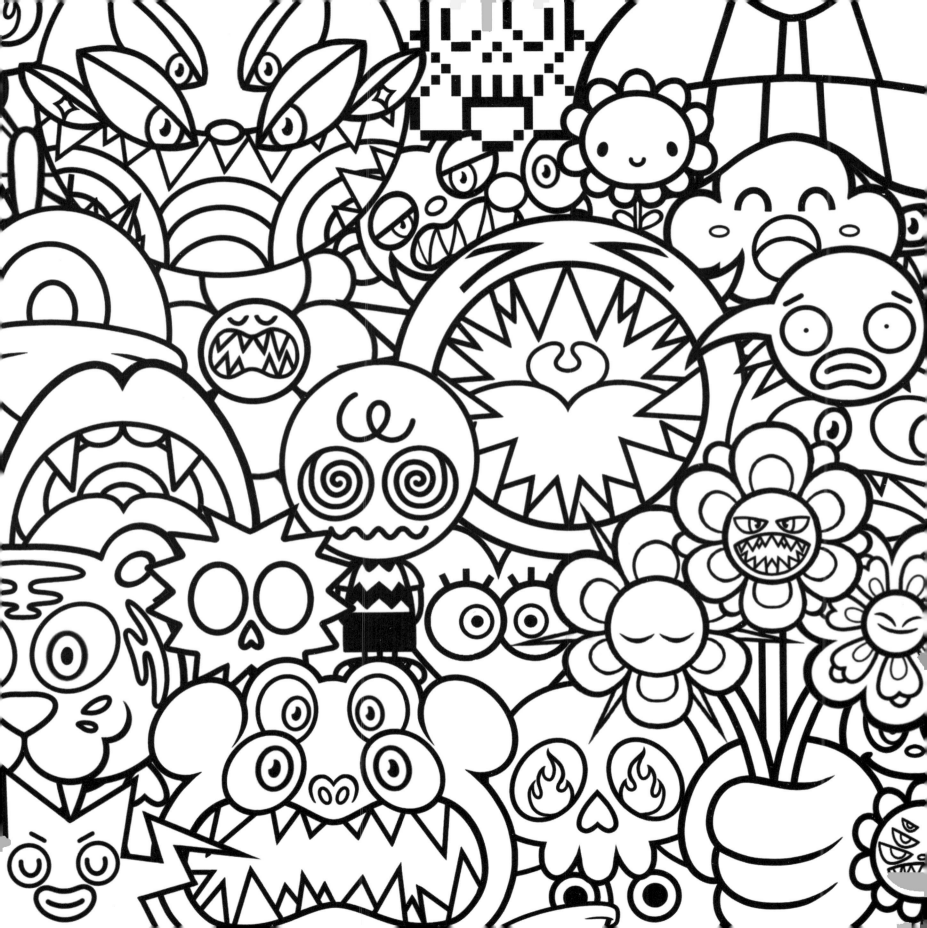

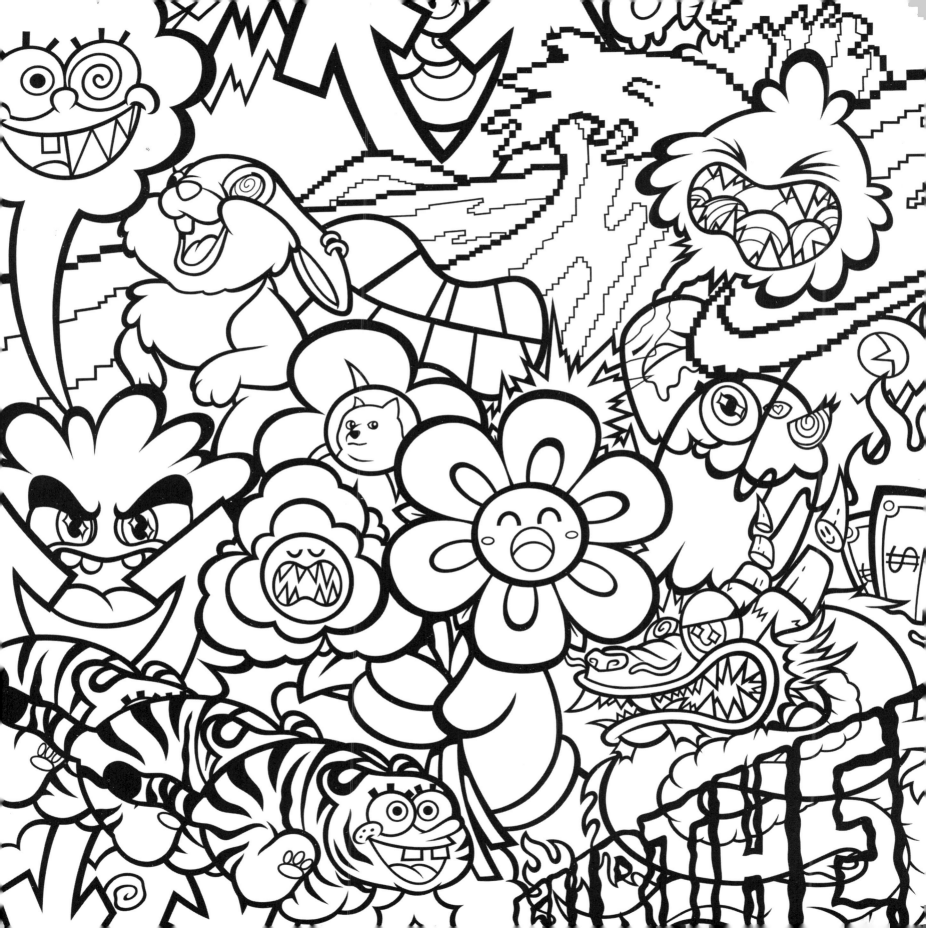

BY BENJII

Benjii is a "visual experimentalist." He is eighteen and currently living in Canada. His favorite colors are neon yellow, hot pink, and sky blue.
Instagram: @benjii.art

&

DONG DONG

Dong Dong is an eighteen-year-old Korean art creator. He is interested in various fields such as art, film, fashion, and photography. He pursues harmony of colors and forms through design across the past, present, and future.
Instagram: @dongdong.art

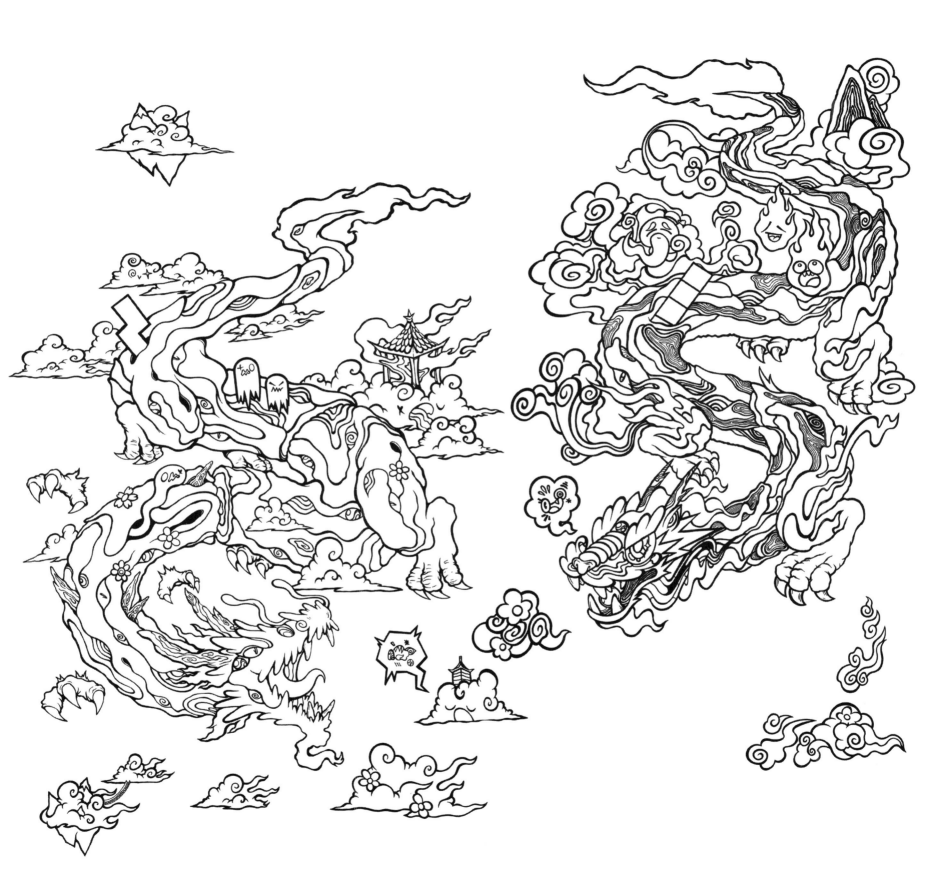

Congratulations on making it to the end of the book!

Feel free to take your favorite artwork and post it on Instagram. Tag @Vexx so I can check it out—I'll be sure to share it on my stories throughout the year. And I may even consider you for participation in our next coloring book! ☺

I hope you've enjoyed the experience. Always remember—keep creating!

I'll see you next time.

—VEXX

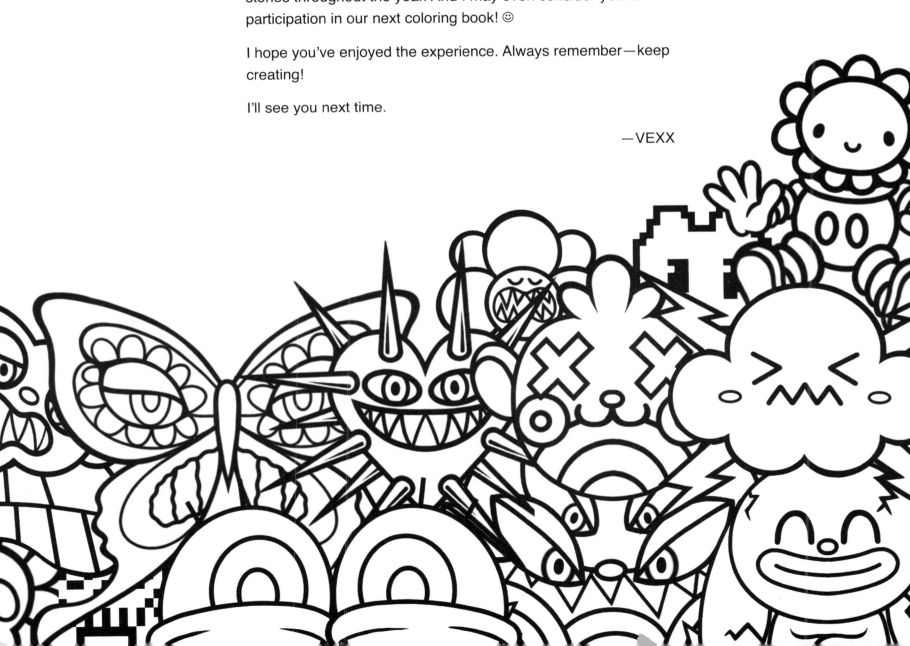

ALSO BY *Vexx*

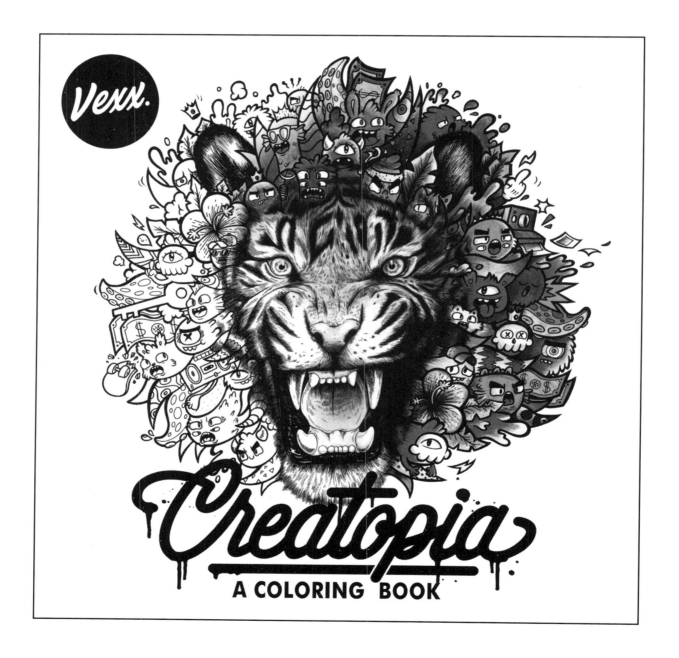

tarcherperigee